D1015410

Dog Love

ANN DeVITO

Penguin Books

P E N G U I N B O O K S

An imprint of Penguin Random House LLC
375 Hudson Street
New York, New York 10014
penguin.com

CIP data available
ISBN 978-0-14-310783-5

Printed in the United States of America
10 9 8 7 6 5 4 3 2 1

Set in Arial MT Pro

For my family
Rick, Quinny, and Ricky

INTRODUCTION

For centuries, dogs have been
an integral part of people's lives.

They are essential in the spiritual
and emotional evolution of humans—
providing us with a sense of the other,
and a deep joy of empathy.

From Schnauzers to Chihuahuas—
mutts, Maltipoos, and more—
enjoy an engaging collection
of portraits exploring the
delightful diversity of dogs.

TYPES OF DOGS

PUREBREEDS
Breeding dogs became popular in the late Victorian era. Through *selective breeding,* dogs with desired traits were bred and dogs with unwanted traits were not. During this time, people developed the idea that being *pure* somehow made dogs superior in appearance and worth.

Today, *purebred* does not mean high quality in health, temperament, or intelligence—it simply means that the dog has known parentage whose ancestors were derived over generations from a recognized breed.

CROSSBREEDS / HYBRIDS / DESIGNER
Designer dogs are intentionally created for desirable traits by crossing two purebred dogs to create a first-generation hybrid. Breeders who design dogs believe their traits can be enhanced by the combination.

Some examples of these crossbred combinations are the Maltipoo (Maltese/Poodle), the Puggle (Pug/Beagle), and the Labradoodle (Labrador Retriever/Poodle).

MIXED BREEDS / MUTTS
Mixed breeds, mongrels, or mutts are dogs that are not a result of breeding and belong to no breed. In the United States, *mixed breed* is the favored term among many who want to avoid the negative connotations associated with *mongrel* and *mutt.*

Hybrid vigor is a theory that suggests dogs of varied ancestry are healthier than their purebred counterparts. Some trainers believe mutts exhibit higher intelligence.

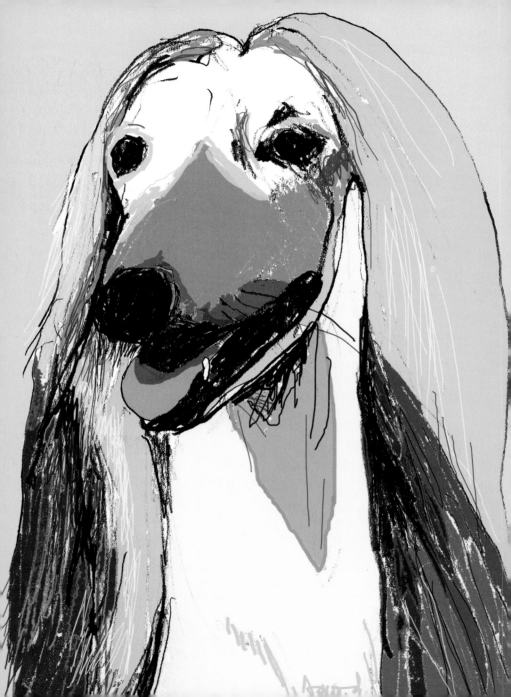

AFGHAN HOUND

Afghan Hounds are considered the supermodels of the dog world, with their swift grace, aloof attitudes, and perfectly curled tails.

In their native home of Afghanistan, these dogs were valued for their agility in hunting hares, gazelles, and wolves.

They can gallop up to 40 mph and leap seven feet from a standing position.

In 1931, Zeppo Marx (of the Marx Brothers) and his wife brought two Afghan Hounds, Asra of Ghanzi and Westmill Omar, to the United States for breeding.

"Right now I have an Afghan Hound named Kabul. He is elegant, with graceful proportions, and I love the way he moves. . . . Often, if he comes into my mind when I am working, it alters what I do. The nose on the face I am drawing gets longer and sharper. The hair of the woman I am sketching gets longer and fluffy, resting against her cheeks like his ears rest against his head."

—PABLO PICASSO

AIREDALE TERRIER

Airedales are the largest of all terriers.
Originating in the Aire Valley
of Yorkshire, they were bred
to catch otters in the river
and rats on land.

Outgoing, and confident,
Airedales have a delightful
playful streak—
romping,
bouncing,
tossing toys,
stealing socks,
grabbing food,
creating mischief.

Airedales mature slowly.
They are independent and intelligent—
courageous, athletic, and protective of
family. Daily walks and romps required.

"An Airedale can do anything any other dog can do
and then lick the other dog if he has to."

—THEODORE ROOSEVELT

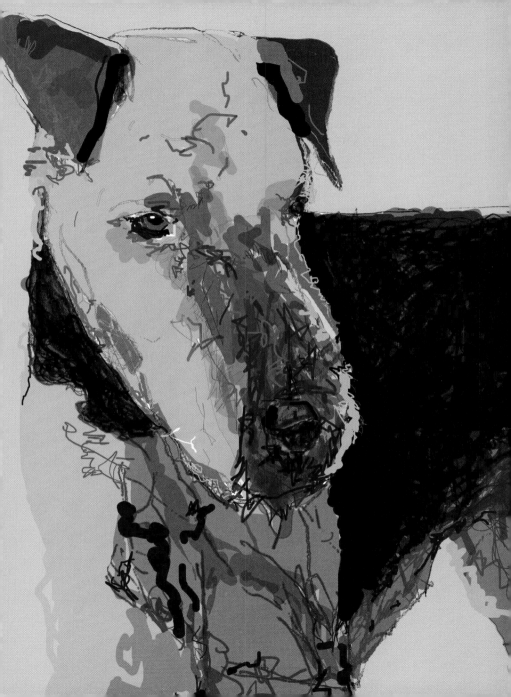

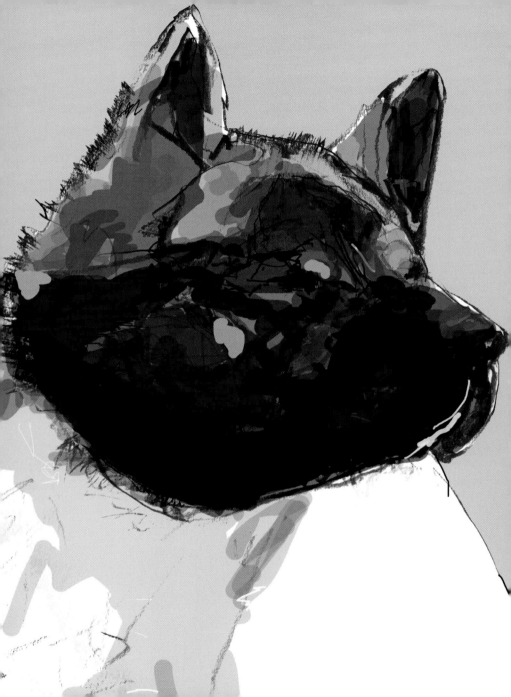

AKITA

Fierce as samurais,
Gentle as kittens,

Akitas are an ancient breed
originating in Japan—they're
bred to hunt large quarry
like bears, boars, and elk.

Their topcoats are coarse
and straight—undercoats
are soft and dense.

White, brindle, or pinto.

Conscious of stature—
instinctually dominant,
they will take place as
pack leader if their
human does not.

Distinguished.
Devoted.

Calm.
Not lazy.

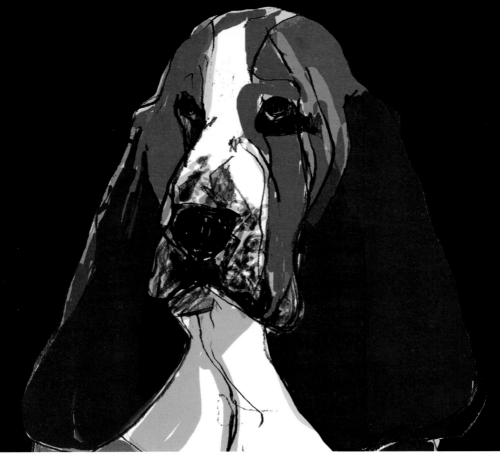

BASSET HOUND

With their short, noble appearance and placid personalities, Basset Hounds are droopy, slow-paced tracking dogs. The name Basset comes from the French word *bas*, meaning "low." Although, rarely taller than fourteen inches, they are considered big dogs, but on short legs.

They have loose skin on their faces—making them look sad. Their long, low ears drag on the ground, stirring up scents, while their folds and wrinkles further capture the scented air.

Their distinct bark is loud and lingering, and they frequently howl at the moon when thunderstorms loom. Basset Hounds come in classic tricolor patterns of black, tan, and white.

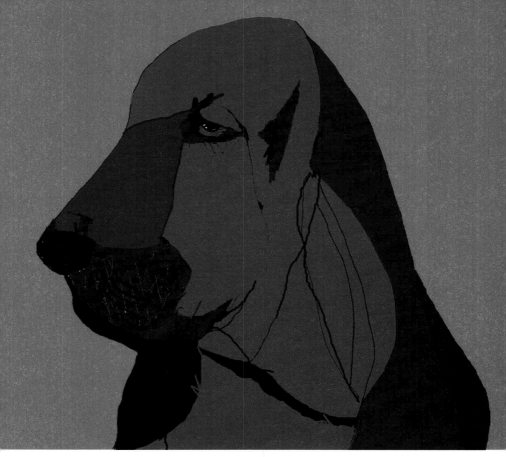

BLOODHOUND

Owned historically by noblemen and aristocrats, Bloodhounds got their name from *blue bloods*. It is believed that William the Conqueror, born 1028 AD, brought Bloodhounds to Britain from Belgium, where the breed originated.

Known as "detectives" of the dog world, Bloodhounds were used to track thieves and poachers for England's law enforcement. Today, the U.S. courts of law allow evidence recovered with the help of Bloodhounds.

Humans use 12 million olfactory receptor cells to smell.
Most dogs use 1 billion. Bloodhounds use 4 billion!

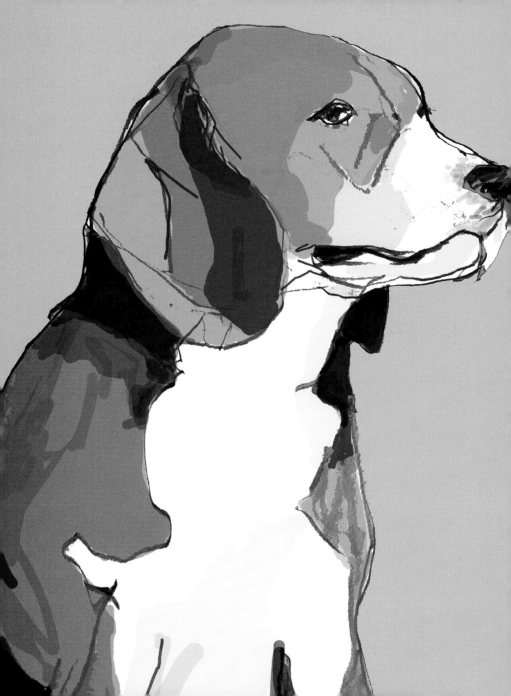

BEAGLE

Beagles have powerful noses and are
always searching for interesting trails.
The U.S. Department of Homeland
Security trains a Beagle Brigade to
sniff out contraband food brought
into airports.

Brown hazel eyes,
soft pleading expressions—
their hound nature makes them
inquisitive, determined, and focused.

Being pack dogs, they are happiest
around other dogs and people.

Pure Beagles have white-tipped tails
with tricolored coats that start out
black and white—gradually turning
brown while losing black.

They have distinct sounds—
a barking growl and a baying howl.
It is believed their name comes from
the Old French word *beegueule*,
literally meaning "open-mouthed."

"Happiness is a warm puppy."
—CHARLES M. SCHULZ

Charles M. Schulz created the most famous fictional Beagle in pop culture.
Snoopy, from the Peanuts comic strip, was a Beagle adopted by Charlie
Brown. For the first several years of the strip, Snoopy was silent. He
eventually developed an active imagination and a rich inner monologue.

BEDLINGTON TERRIER

Bedlington Terriers are
from England, said to have
evolved from Otterhounds
and Dandie Dinmont Terriers.
They were primarily used for
hunting foxes, badgers, and
small game.

Lovable with big hearts,
they have woolly coats
that are dark as puppies,
fading to a light gray.
Like a lamb.

Bedlingtons are intelligent,
and their intelligence makes
them easy to train. Positive
techniques such as praise,
play, and treats work.

They can be willful.
Begin a battle of wills—
you will probably lose.

"The only creatures that are evolved enough
to convey pure love are dogs and infants."

—JOHNNY DEPP

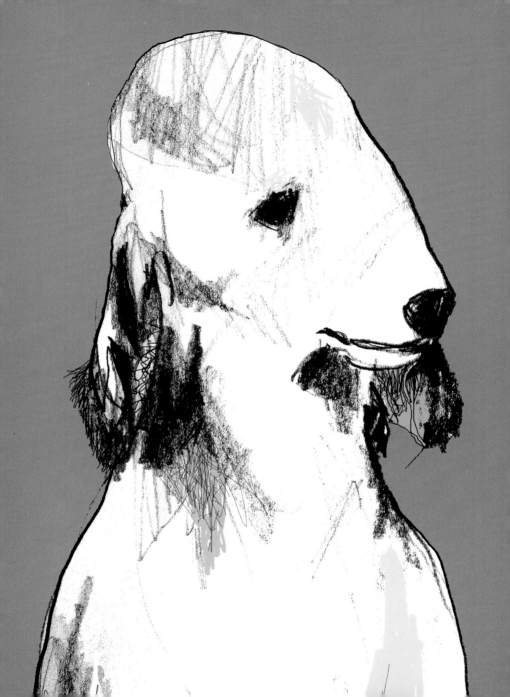

BICHON FRISE

Bichons Frises hark back to the Mediterranean, particularly Spain and France. The Spanish painter Francisco de Goya included these dogs in many of his works.

Beginning around the fourteenth century, Spanish sailors brought Bichons Frises along as companions while traveling between continents.

The dogs were so friendly, they helped sailors bond with strangers in foreign countries, and they were also used for bartering. Despite being sailor companions, Bichons Frises dislike water.

Compact with baby doll faces, fluffy white coats, and black eyes.

They love to be loved.

"What do dogs do on their day off?
They can't lie around—that's their job!"

—GEORGE CARLIN

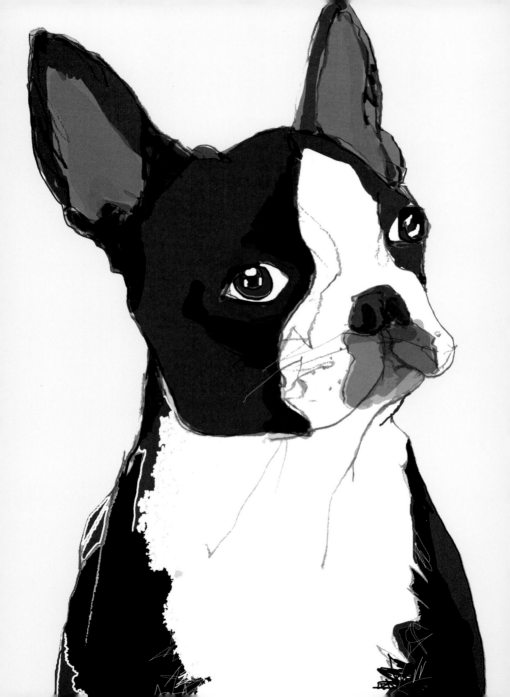

BOSTON TERRIER

The Boston Terrier is nicknamed
"the American Gentleman" for its
gentle disposition and dapper looks.

Highly intelligent, compactly built,
these dogs were bred after the Civil
War for sport fighting. Hard to believe
these little stylish dogs were tough
pit fighters.

Lightweight.
Middleweight.
Heavyweight.

Originating in Boston, Massachusetts,
Boston Terriers were the first dog breed
from the United States to be recognized
by the American Kennel Club, in 1893.

Patient with kids.
Trusted with elders.
Friendly with strangers.

Helen Keller had a Boston Terrier named Phiz,
given to her by classmates at Radcliffe College.

BOXER

Boxers were bred to hunt large animals.
Their tails are docked and ears are cropped
to prevent their prey from grasping them
during a struggle.

They are descendants of Bulldogs and
the (now-extinct breed) Bullenbeisser.
Germans refined their appearance and
behavior throughout the nineteenth century.

Boxers gained popularity in the United States
after World War II, when soldiers adopted and
brought them home after using them as military
attack, guard, and messenger dogs.

Alert and agile,
exuberent and energetic—
Boxers need plenty of exercise
or they will chew, dig, and lick
everything!

TRUE or FALSE? Boxers were named for their tendency
to stand on their hind legs, and punch and jab with their paws.

Answer: True and false. There is a lot of debate over (and no recorded history of)
the origin of the Boxer's name. Some theorize the name derived from Bullenbeisser,
evolving to Bierboxer to Boxi and finally Boxer over time. Or it came about simply
in appreciation of the dogs' fighting qualities—rather than their technique.
The German dictionaries translate the word *Boxer* as "prize fighter."

TRUE or FALSE? There is no such thing as a black Boxer.

Answer: True. Boxers are brindle, fawn, or white (although
white Boxers are not recognized by the American Kennel Club).

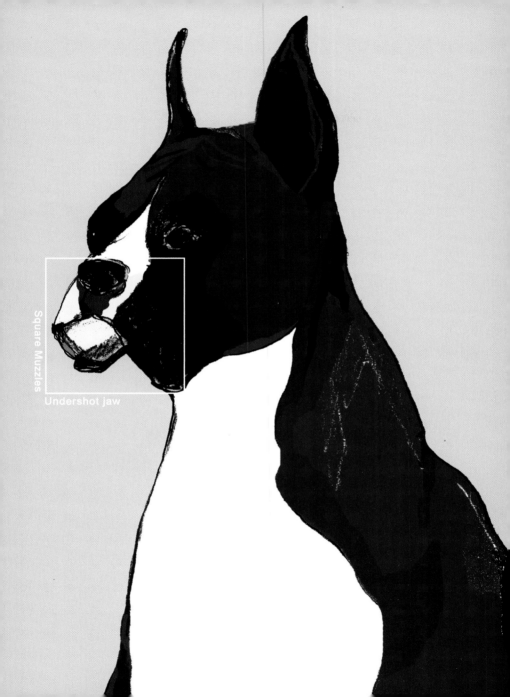

Square Muzzles

Undershot jaw

BULLDOG

Bulldogs originated
in the British Isles
and were once used
to guard, control,
and bait bulls.

Short and stout,
with wide shoulders
and sturdy legs, today's
Bulldogs are happy
lying low.

Dignified and resolute.

Patient with kids,
stubborn at times,
their soothing, mellow,
"no worries" personality
is often mistaken for
lazzzzzziness.

Like many large-skulled dogs,
they do not move well in water
and are in danger of drowning
when swimming.

Grunt, snuff,
wheeze, drool.
Snoring loudly.
Seldom barking.

"A dog's got personality.
Personality goes a long way."
—*PULP FICTION*

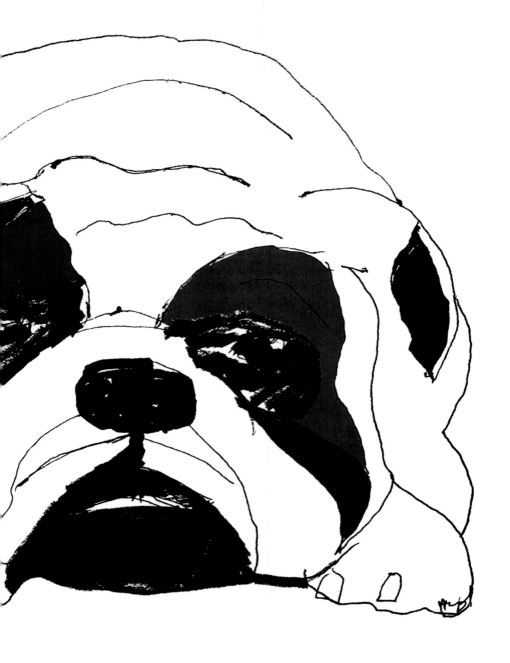

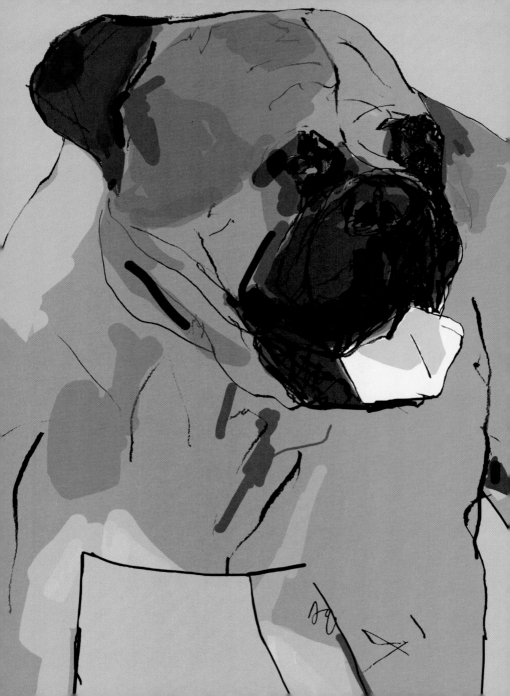

BULLMASTIFF

Bullmastiffs are firm
and fearless. Originally
bred from Mastiffs and
Bulldogs in England,
they are courageous,
confident guardians
of the grounds.

Weighing up to 130 pounds,
large and powerfully built,
their appearance will deter
intruders and attackers.

Despite their size,
Bullmastiffs are not
high-energy dogs.

Trained and socialized
Bullmastiffs are noble,
trustworthy huggable lugs.

They come in three colors:
red, fawn, or brindle, with
dark muzzles and ears.

"Dogs are our link to paradise.
They don't know evil or jealousy
or discontent. To sit with a dog on
a hillside on a glorious afternoon
is to be back in Eden, where doing
nothing was not boring—
it was peace."

—MILAN KUNDERA

BULL TERRIER

Bull Terriers were developed in the nineteenth century as fighting dogs and later became fashionable companions to gentlemen, who nicknamed them the White Cavaliers for their courageous and courtly disposition.

Known for their egg-shaped heads, clown personalities, and triangular eyes, they are happy, active, and attached to their people. Not for timid owners.

A bored Bull Terrier will chew, search, and destroy. Their rough-and-tumble play is ideal for older active children. Tireless playmates—chasing balls for hours.

They have natural guardian instincts and rarely bark—except for good reason.

Put a winter coat on a Bull Terrier, he will probably eat it.

Bull Terrier Mascots
Spuds MacKenzie for Budweiser
Bullseye for Target

In 1981, a Bull Terrier appeared on Rick Springfield's *Working Class Dog* album cover.

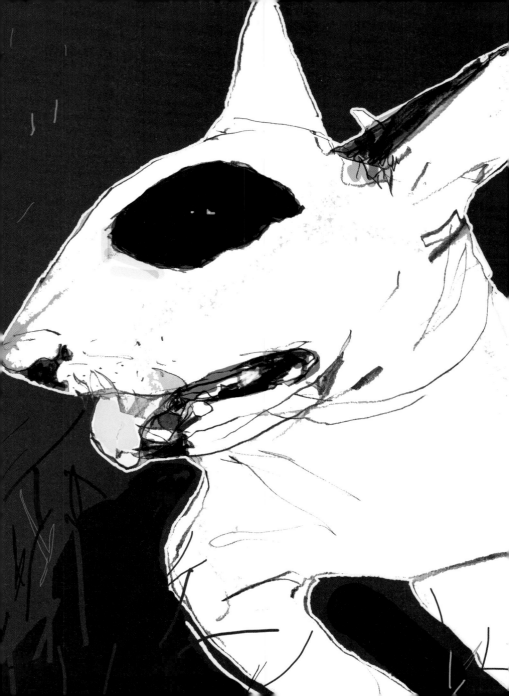

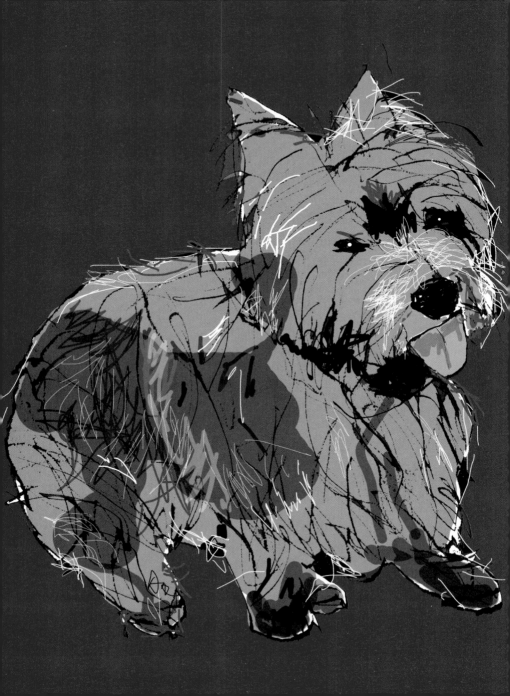

CAIRN TERRIER

Cairn Terriers are one of the oldest
and smallest terrier breeds. They were
originally bred in the vast open plains
of the Scottish Highlands where the only
form of landmark markers were piles
of stones called cairns.

Cairn Terriers hunted vermin and small
game that lived in and around the cairns.

On average, they stand ten inches tall
and weigh 12 to 14 pounds—
sturdy and strong.

Unkempt and scrappy.
Independent and spunky.
Curious and sensitive.

Cairns have a natural love of children
and are tough enough to endure kids' play.

One of the most recognizable Cairn Terriers in popular culture
is Dorothy's dog, Toto, in the 1939 film *The Wizard of Oz*.

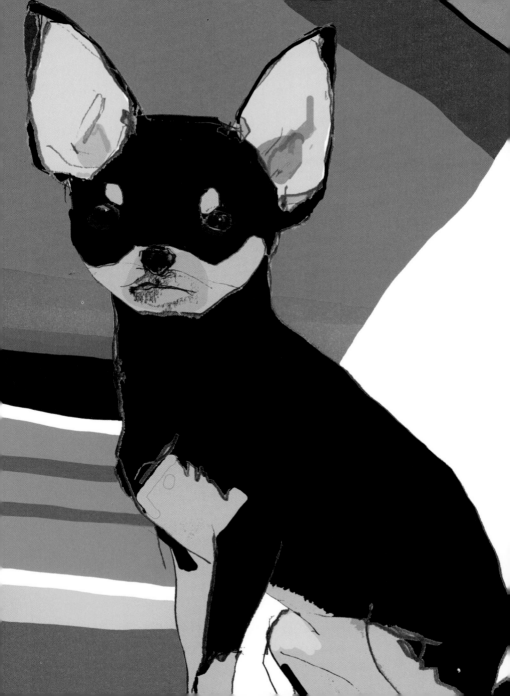

CHIHUAHUA

Meet the world's smallest dog.
Short-haired Chihuahuas were
discovered in the Mexican state
of Chihuahua.

Despite their size—4 to 7 pounds—
they make excellent watchdogs.
They are naturally alert and
suspicious towards strangers.

Chihuahuas are fun explorers
with feisty personalities. They
love nothing more than being
close to their family.

Put them in your bag
and *vámonos!*

Warning: Not for rowdy,
rambunctious children.

Notable Chihuahua Owners
Cesar Millan–Coco and Taco
Paris Hilton–Tinkerbell and Bambi
Marilyn Monroe–Choochoo
Sharon Osbourne–Martin

CHINESE CRESTED

Chinese Cresteds (Cresties or Puffs)
aren't originally from China. Their roots
trace back to Africa; their ancestors were
known as the African Hairless Terriers.
Chinese traders encountered them in Africa
and adopted, refined, and renamed them.

Cresties are famous for being ugly.
Beauty is in the eye of the beholder.

There are two types of Chinese Cresteds:
Powder Puff—straight hair covering body.
Hairless—tufts of silky hair on head (crest),
tail (plume), and feet (socks).

Polite, clean, and quiet.

Chinese Cresteds are small pixies,
measuring 11 to 13 inches and
weighing 10 to 12 pounds—
small enough to travel in your bag,
wear a sweater, and sit on your lap.

Protect them from extreme weather conditions.

"The dog is dressed just like me at the climax of my act."

—GYPSY ROSE LEE

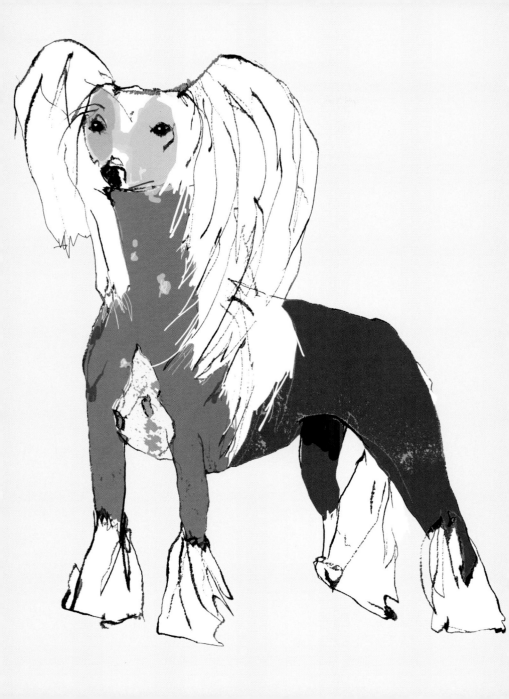

CHOW CHOW

Chow Chows combine
the nobility of a lion,
the whimsy of a panda,
the grace of a cat, and
the devotion of a dog.

Dignified and aloof.
Proud and independent.

Chows are an ancient,
lionlike breed from China
with powerful heavy bones.

They come in five colors:
red, black, blue, cinnamon,
and cream.

Chows have purple tongues,
and bushy coats to keep warm.

Notable Chow Chow Owners
President Calvin Coolidge
Martha Stewart
Sigmund Freud

Queen Victoria had a beloved Chow
Chow puppy that she carried everywhere.
Her friends disapproved, saying it did not
befit a queen to be seen everywhere with
a dog, so they paid a dressmaker to make
a stuffed version for her that resembled a
teddy bear.

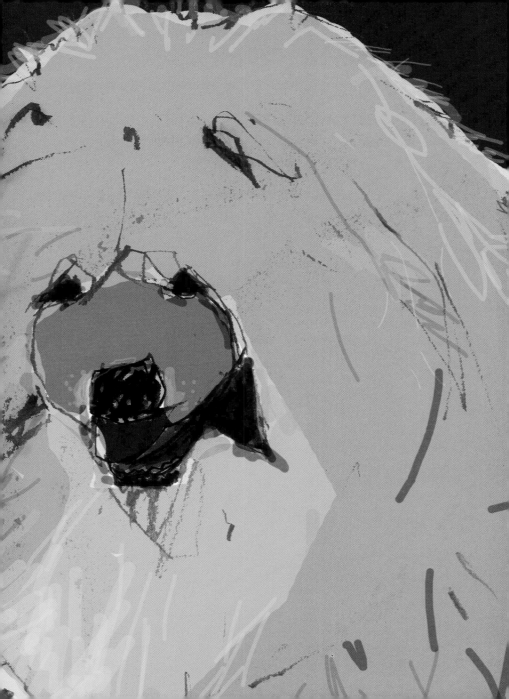

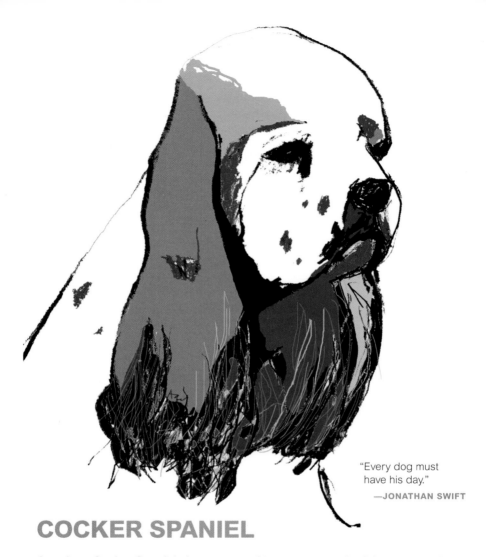

"Every dog must
have his day."

—JONATHAN SWIFT

COCKER SPANIEL

American Cocker Spaniels have a sound temperament. Joyful, merry, and
trusting. Cooperative, eager, and excited. Listening, understanding, and happily
obeying commands. They have round heads, fluffy, long ears, and silky coats
ranging in color.

Cocker Spaniels were the most popular dog in America for sixteen years
straight (1936 to 1952)—a run that has yet to be matched by another dog.

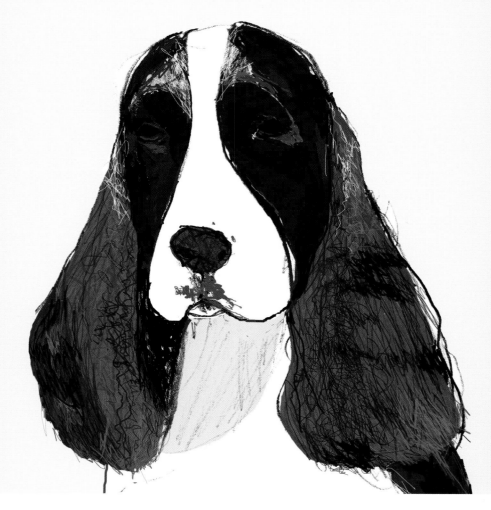

ENGLISH SPRINGER SPANIEL

English Springer Spaniels are named for the way they *spring* at game. Fly-ball and tracking are favorite athletic activities. Their enthusiastic and affectionate nature makes them excellent therapeutic dogs.

Medium in size with gentle expressions and drop ears—their body is protected by a dense coat adorned with long feathery fringe hair on ears, chest, legs, and belly. English Springer Spaniels and Cocker Spaniels are separate breeds.

COLLIE

Collies are from the borderlands
of England, Scotland, and Wales.
They were used to herd sheep,
cattle, goats, and pigs.

There are several different types of
Collies: Rough, Smooth, Bearded,
Border, and Shetland.

Extremely intelligent and sensitive,
they are known for their uncanny
ability to detect when something
is wrong. Stories about Collies
rescuing people and other
animals are abundant.

Their herding instincts are strong—
it's not unusual for them to gather
children, chase cars, and bark.

Collies are medium-size dogs,
50 to 70 pounds, with pointed snouts,
long (Rough) or short (Smooth) coats
in different colors—combinations of
sable, mahogany, gray, blue, silver,
and white.

Lassie was a fictional Rough Collie dog in the novel *Lassie Come-Home* by
Eric Knight. A Collie named Pal and later his offspring went on to star in the
1950s television series Lassie.

During World War I, the U.S. military attempted to train Collies as protection
and attack dogs. More than 90 percent failed. They were too friendly!

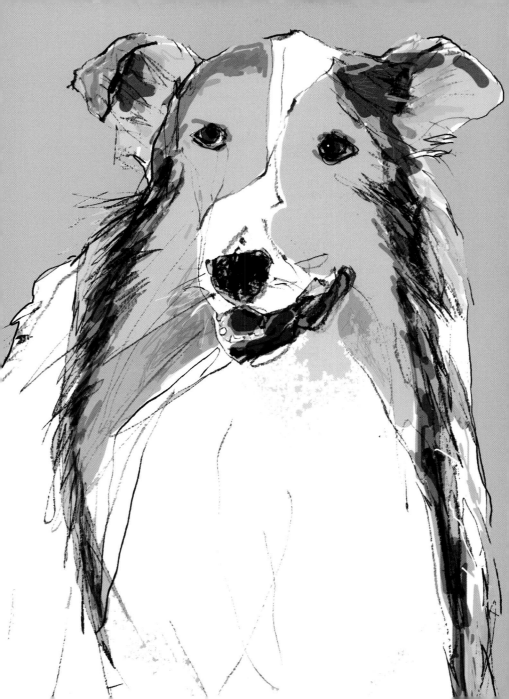

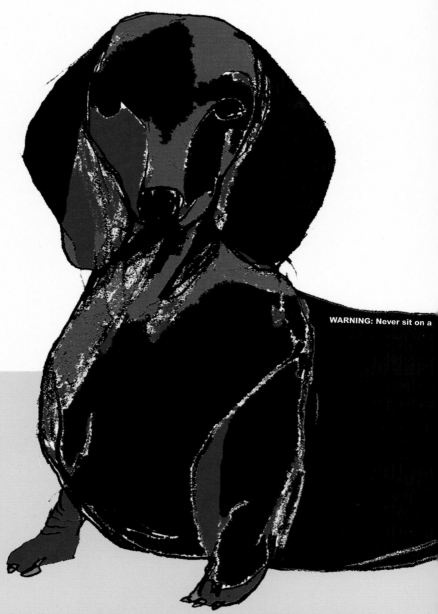

WARNING: Never sit on a

David Hockney found inspiration from his dachshunds, Stanley and Boodgie. They were the featured attraction in approximately forty-five oil paintings in his 1995 gallery show.

Andy Warhol owned two dachshund puppies, Archie and Amos.

DACHSHUND

Dachshunds were bred to scent, chase, and flush out burrow-dwelling animals, like badgers. Their name literally means "badger dog" in German.

Affectionately nicknamed wieners, sausages, or hot dogs, Dachshunds have short, stubby legs and elongated bodies.

They chase rabbits and tennis balls with great determination.

They love other dachshunds, and frequently travel in pairs, burrowing in blankets to snuggle and sleep.

Longhaired or short.

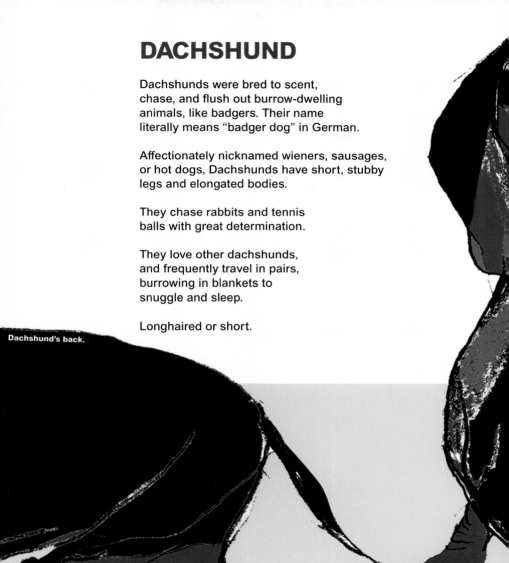

Dachshund's back.

Pablo Picasso had a Dachshund muse named Lump (pronounced "loomp," meaning "rascal" in German). Their relationship is chronicled in *Picasso and Lump: A Dachshund's Odyssey* by photographer David Douglas Duncan, who gave Picasso the dog.

GALLANTLY
GOOFY

ATHLETIC
ENERGY

THE
FIRE
DOG

BORN
TO RUN

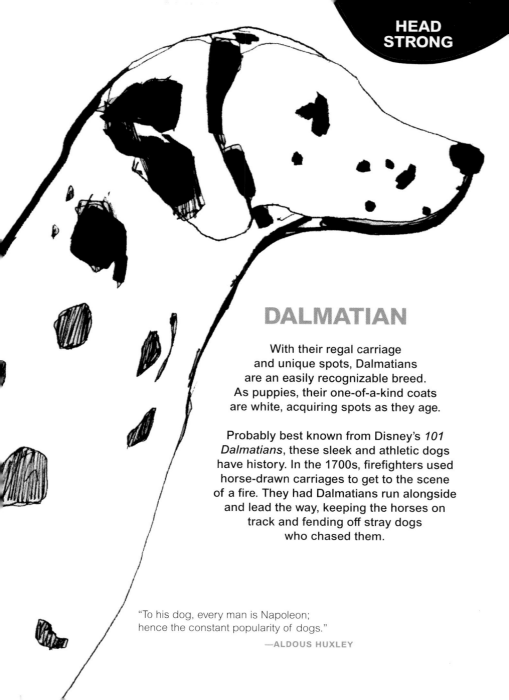

DALMATIAN

With their regal carriage
and unique spots, Dalmatians
are an easily recognizable breed.
As puppies, their one-of-a-kind coats
are white, acquiring spots as they age.

Probably best known from Disney's *101 Dalmatians*, these sleek and athletic dogs have history. In the 1700s, firefighters used horse-drawn carriages to get to the scene of a fire. They had Dalmatians run alongside and lead the way, keeping the horses on track and fending off stray dogs who chased them.

"To his dog, every man is Napoleon;
hence the constant popularity of dogs."

—ALDOUS HUXLEY

DANDIE DINMONT
TERRIER

Dandie Dinmont Terriers are little, unique dogs named after a fictional character. They gained notoriety and a name in Sir Walter Scott's book *Guy Mannering*, published in 1815.

In the book, a farmer has six small, long terriers. The farmer's name is Dandie Dinmont and the little dogs came to be known as Dandie Dinmont's Terriers, with the apostrophe and *s* eventually being dropped.

The fictional farmer had two names for his little Dandies: Pepper and Mustard.

He differentiated them as Auld Pepper, Auld Mustard, Young Pepper, Young Mustard, Little Pepper, and Little Mustard.

Today the two colors of the breed are still known as Pepper (bluish black) and Mustard (shades of golden brown).

Dandies are rare, short-legged, long-bodied dogs with a distinct *poof* of hair on their big dome heads.

Low, long ears, fringed at the tips. Large chests and curved backs. Hind legs slightly longer than front legs, and not as heavy. Height: 8 to11 inches. Weight: 18 to 24 pounds.

Affectionate and lively. Dignified and determined.

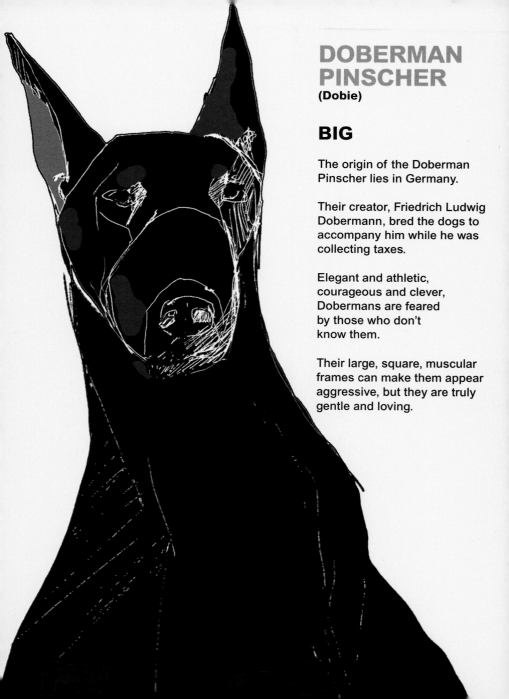

DOBERMAN PINSCHER
(Dobie)

BIG

The origin of the Doberman Pinscher lies in Germany.

Their creator, Friedrich Ludwig Dobermann, bred the dogs to accompany him while he was collecting taxes.

Elegant and athletic, courageous and clever, Dobermans are feared by those who don't know them.

Their large, square, muscular frames can make them appear aggressive, but they are truly gentle and loving.

MINIATURE
PINSCHER
(Min Pin)

Little

Min Pins are King of the Toys—
tough little dogs with dynamite
personalities. They look delicate
but are quite sturdy and walk
with bold confidence.

While Min Pins look like small
versions of Dobermans, the two
are different breeds with the
same last name.

"My little dog—
a heartbeat at my feet."

—EDITH WHARTON

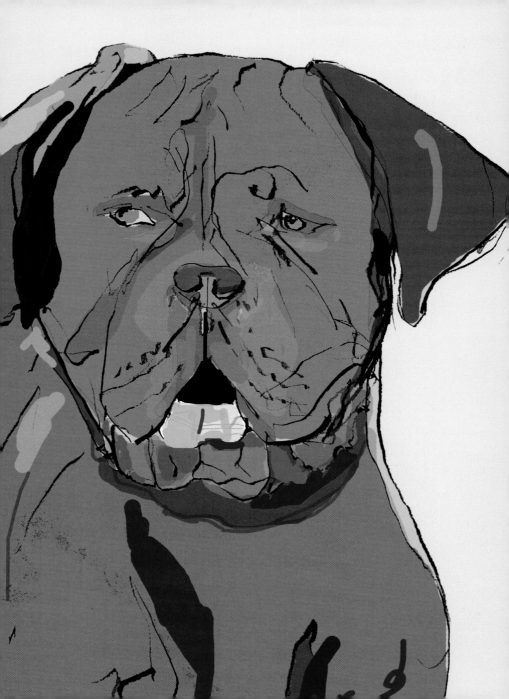

DOGUE DE BORDEAUX

Originating in France's Bordeaux
region 600-plus years ago, Dogues
de Bordeaux (DDBs or French Mastiffs)
were imposing guards known for their
fearless temperament and massive heads.

Burly and powerful with oval eyes, small
ears, broad noses, flared nostrils, stocky
muzzles, and underbites.

Skin is thick and loose.
Coats are shades of fawn
and easy to groom.
Thick tails are low.

Sweet and docile or
stubborn and arrogant—
they are loyal guards.

To prevent aggression,
train and socialize them
with stern, firm leadership.

Prone to snore, slobber, and slime.

Dogue de Bordeaux caught the attention of the American public
with the 1989 release of *Turner and Hooch* starring Tom Hanks.

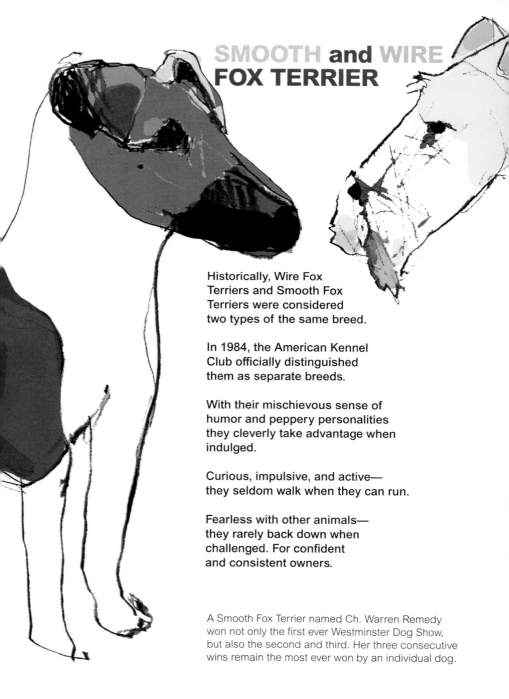

SMOOTH and WIRE
FOX TERRIER

Historically, Wire Fox
Terriers and Smooth Fox
Terriers were considered
two types of the same breed.

In 1984, the American Kennel
Club officially distinguished
them as separate breeds.

With their mischievous sense of
humor and peppery personalities
they cleverly take advantage when
indulged.

Curious, impulsive, and active—
they seldom walk when they can run.

Fearless with other animals—
they rarely back down when
challenged. For confident
and consistent owners.

A Smooth Fox Terrier named Ch. Warren Remedy
won not only the first ever Westminster Dog Show,
but also the second and third. Her three consecutive
wins remain the most ever won by an individual dog.

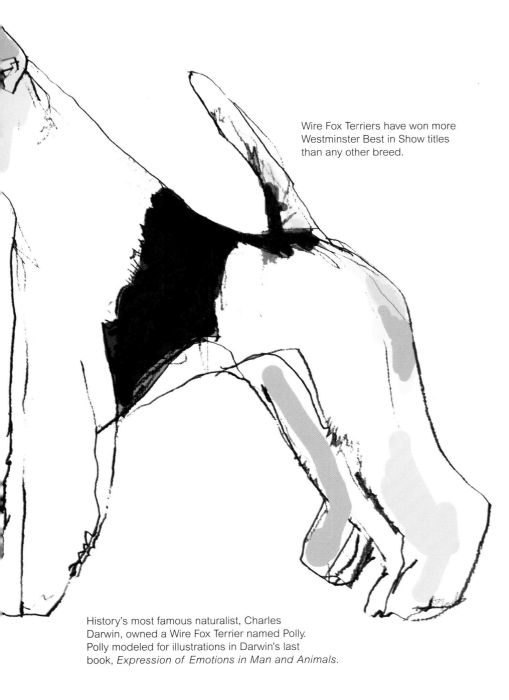

Wire Fox Terriers have won more Westminster Best in Show titles than any other breed.

History's most famous naturalist, Charles Darwin, owned a Wire Fox Terrier named Polly. Polly modeled for illustrations in Darwin's last book, *Expression of Emotions in Man and Animals.*

FRENCH BULLDOG
(Frenchie)

Despite their name, French Bulldogs
originated in Nottingham, England.
They were created to be a toy-size
version of the Bulldog.

When English artisans lost their jobs in the
Industrial Revolution, many fled to France in
search of better opportunities, bringing their
dogs with them. Their popularity in France
quickly outpaced that in England.

Frenchies are small—
11 to12 inches tall,
20 to 30 pounds—
but substantial.

With their muscular bodies and easygoing
personalities, they love to play…but also
enjoy spending their days relaxing.

French Bulldogs have bat ears and flat faces.
They snore, do not like extreme heat or cold,
and sink in the water. Their coats are short.

Loyal and loving companions.

Frenchies on the *Titanic*

Robert W. Daniel brought his French Bulldog with him on board the *Titanic*. Two
years old, Gamin de Pycombe was a champion show dog who had cost Daniel
the equivalent of about $18,500 today. Daniel survived the disaster and lived until
1940. Gamin de Pycombe was not as fortunate. He was last seen swimming in the
freezing water.

Only three dogs on the *Titanic* survived: a Pekingese owned by Henry Harper, a
Pomeranian owned by Margaret Hays, and Elizabeth Rothschild's Pomeranian.

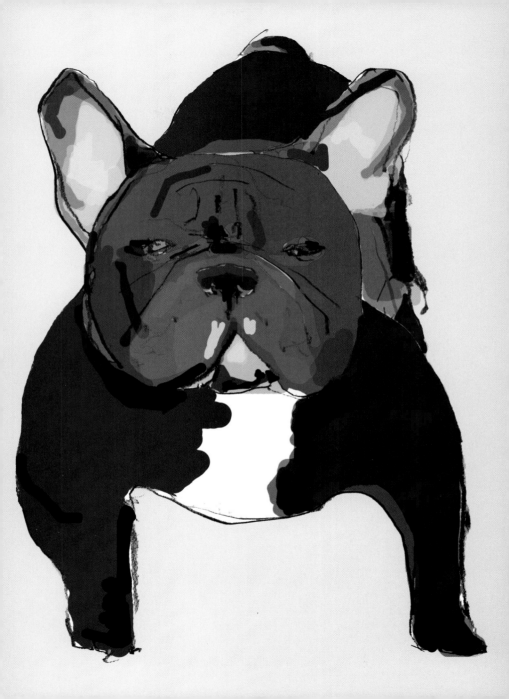

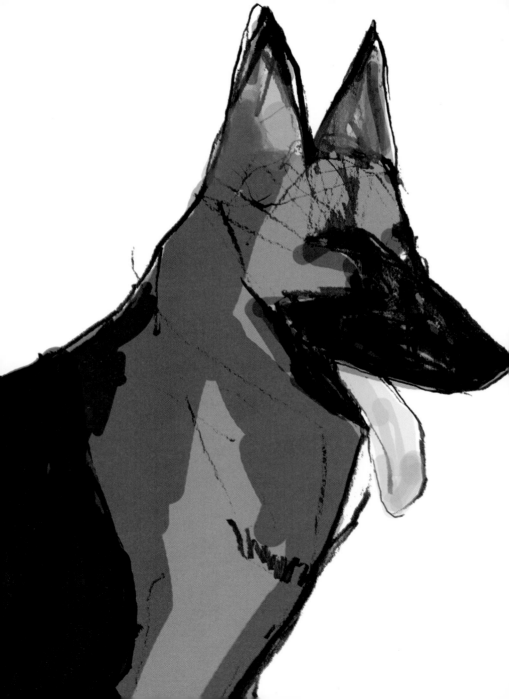

GERMAN SHEPHERD

After Border Collies and Poodles,
German Shepherds are the third most
intelligent type of dog in the world.

Cuddly teddy bears to those who care
for them—cold as ice to those who don't.
German Shepherds are not fond of lazy
days, and a knock on the door guarantees
a deep, ferocious-sounding bark.

Adult Shepherds can
instantly run top speed,
come to a sudden stop,
and round a corner
without stumbling—
one of many reasons
they're used as police
and military dogs.

A mix of beige and black,
German Shepherds grow
up to two feet tall and
weigh 50 to 90 pounds.

Ears are large and pointed.
Tails are long and bushy.
Hearts are filled with love.

Notable German Shepherds
Rin Tin Tin made twenty-seven movies for Warner Bros.
Pictures over the course of nine years.

Buddy became the first Seeing Eye dog in 1928.

GOLDEN RETRIEVER

Golden Retrievers are the fourth most
intelligent dogs in the world after Border
Collies, Poodles, and German Shepherds.

Bred as retrieval hunting dogs,
Goldens have an extremely powerful
sense of smell. Today they work as
bomb sniffers, in search and rescue,
or as therapy dogs.

They are diligent workers,
and love having jobs like—
retrieving the paper,
waking up the family,
or competing in sports.

Strong swimmers, built for action,
they love outdoor romps like hiking,
jogging, and playing catch.

Vigorous exercise for 20 to 30
minutes twice a day will keep them
mellow in the evenings. They are
crepuscular animals—more active
during dawn and dusk.

The recent true story of Murphy, a lost Golden found after twenty months surviving alone in
a California forest, is astounding. When a sighting of Murphy was reported, the family left
Murphy's old blanket at the location. Murphy was found sleeping on it a week later.

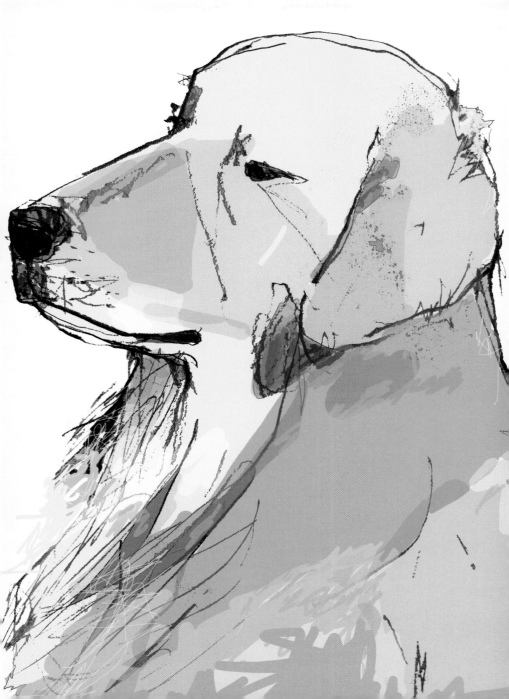

GREAT DANE

Great Danes are known as the Apollo of all Dogs—historically admired for their ability to bring down wild boar and bears.

Despite the breed's name, Great Danes do not have Danish origins. They are from Germany, where they are called *Deutsche Dogge* (German Mastiff).

With their power and large size—120 to 200 pounds—Great Danes are great guards.

Training is a must—or they will take *you* for a walk.

Great Danes often think they are lap dogs.

Pennsylvania's founder, William Penn, was a Great Dane lover—the Great Dane is the official state dog.

Notable Fictional Great Danes
Marmaduke—*Marmaduke* comic strip
Astro—*The Jetsons* cartoon
Scooby—*Scooby Doo* series

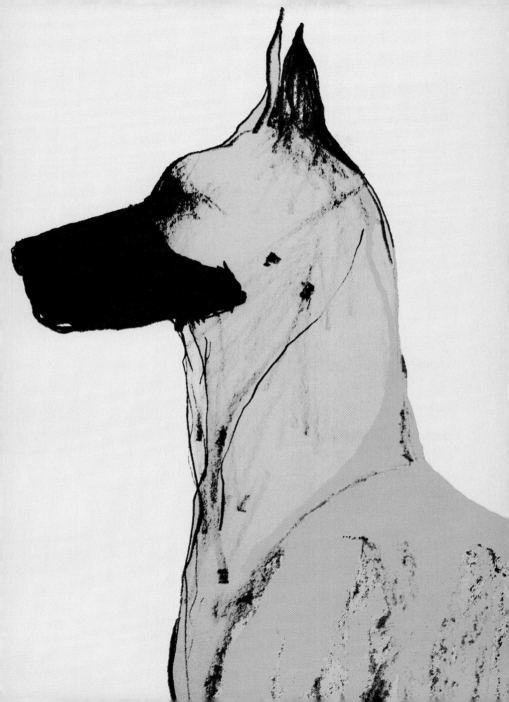

GREATER SWISS MOUNTAIN DOG

Greater Swiss
Mountain Dogs are
one of Switzerland's
oldest breeds.

Originally bred to herd
cattle and pull carts,
today's Swissies excel
in obedience and agility.

Weighing over 100 pounds,
Swissies are big watchdogs.

Gentle at heart,
devoted to family.
Handsome, alert,
and powerful.

Black ears, tail, back, and legs.

Rust cheeks, thumbprint
eyebrows, and legs.

White muzzle, feet, tail tip,
chest, forehead, and nose.

"All knowledge, the totality of all
questions and all answers is
contained in the dog."

—FRANZ KAFKA

GREYHOUND

Greyhounds originated
in ancient Egypt, where
carvings in tombs clearly
depict Greyhound-like dogs.

Swift and graceful, the fastest
of all dogs, with speeds of up
to 45 mph, Greyhounds can
outrun a horse in a sprint and
jump great heights.

Greyhounds are sight hounds—
they rely on their vision more
than their sense of smell.

They have keen eyesight
for fast moving objects,
like running hares.

Their bodies are tall and slender.
Their coats are sleek and smooth.
They walk with dignity and grace.

The Greyhound is the only dog breed mentioned in the Bible. In
Proverbs 30, verses 29–31, they're decribed as having a stately stride.

MYTH: Greyhounds wear muzzles because they are mean.
FACT: Greyhounds wear muzzles while racing, for protection from injury
during the excitement of a chase.

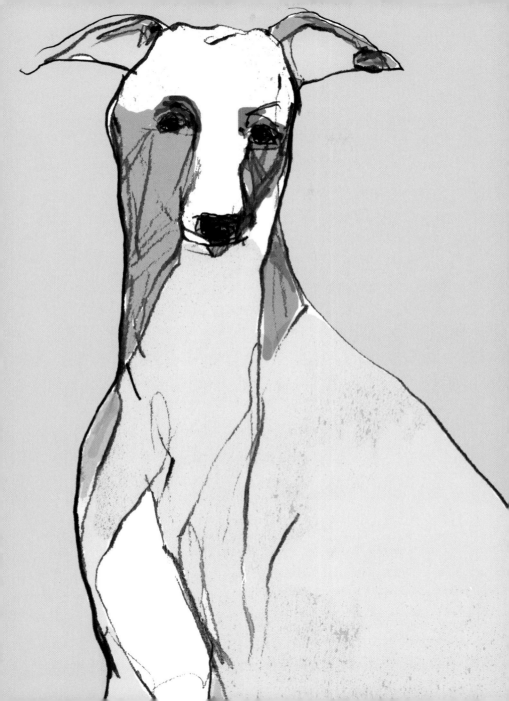

"If aliens are watching this through telescopes,
they're gonna think the dogs are the leaders.
If you see two life forms,
one of them's making a poop,
the other one's carrying it for him,
who would you assume is in charge?"

—JERRY SEINFELD

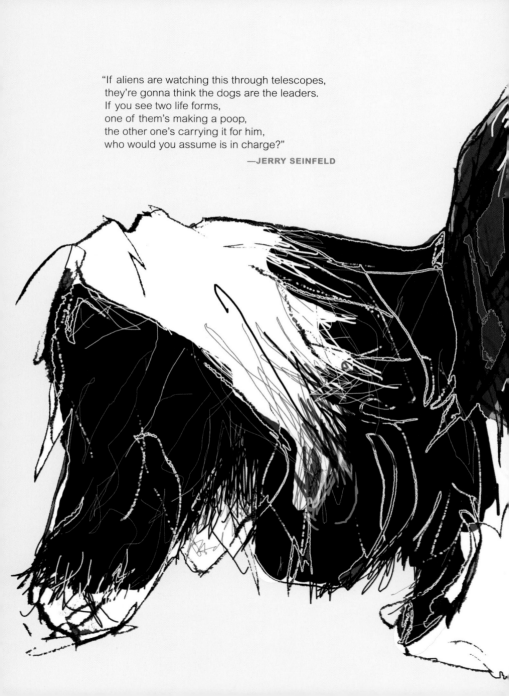

HAVANESE

Originating in Cuba, Havanese are sturdy charmers weighing 7 to 13 pounds.

Their coats are like raw silk floss— profuse, but extremely light and soft, insulating against the strong tropical sun's rays.

Hypo-allergenic: They do not shed.

They are beloved, friendly companions getting along with strangers, children, cats, and other dogs, and can be extremely attached to one owner; earning the nickname "Velcro Dog."

Paper is a favorite toy and can provide hours of shredding pleasure.

Be mindful of overindulgence. They can be cute con artists with their animated faces and endearing head tip.

IRISH SETTER

Irish Setters are rowdy
redheads from Ireland.
Their coats weren't always
red. Owners once preferred
Irish Setters to be red and
white, easier to see in
hunting fields.

As they gained popularity
as show dogs and were used
less for hunting, solid red coats
became the fashionable standard.

Originally developed as bird dogs,
Irish Setters have flamboyance,
drive, and energy.

Running fast and discovering
new places, new birds.

They are fantastic for active families
who love the outdoors. Boisterous and
clownish, they act like puppies for the
first two to three years of their lives.

Presidents Who Owned Irish Setters
Harry Truman—Mike
Ronald Reagan—Peggy
Richard Nixon—King Tim

The Dog Whisperer, Cesar Millan, is known for working with his two Pit Bulls,
Daddy and Junior, but the first dog he owned was an Irish Setter.

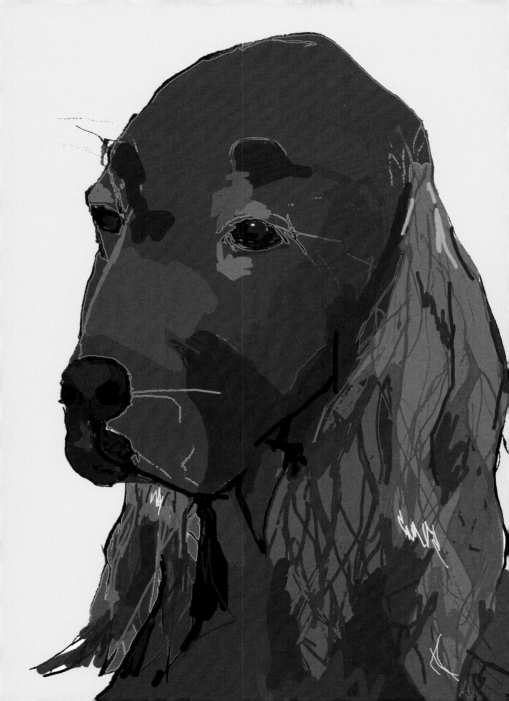

ITALIAN SPINONE

The Italian Spinone (Spinone Italiano)
is an ancient breed from northern Italy.
Some believe these dogs were brought
to Italy by Greek traders during the
Roman Empire.

Their name comes from
an Italian thornbush
known as pine and is
indicative of the breed's
ability to trudge through
thorny bushes.

They move with an easy, free trot
and are powerful swimmers.

Bred for hunting, pointing, and
retrieving, Italian Spinones are
rugged, with a square build,
strong bones, and limbs suited
to any kind of terrain. Their coats
are hard and weatherproof.

With their humanlike eyes,
long eyebrows, beards, and
mustaches—they exude
expressions of clever
intelligence.

Enthusiastic, loyal, and friendly,
Spinones are never bossy or whiny—
they are well mannered and sensitive.

"The dog is a gentleman; I hope
to go to his heaven, not man's."

—MARK TWAIN

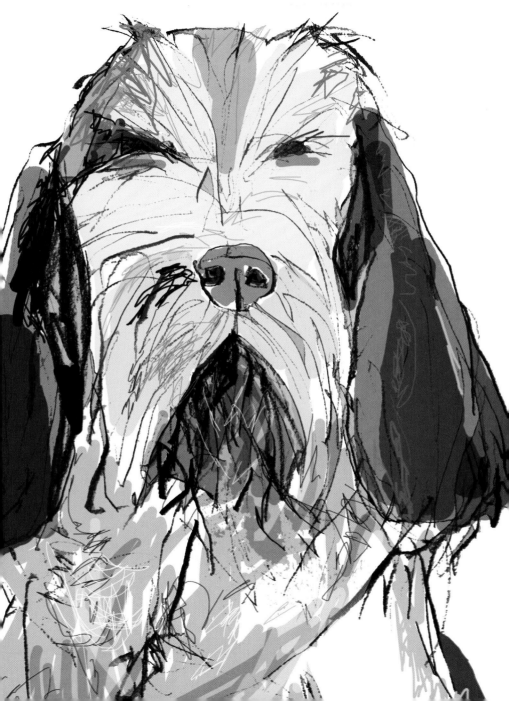

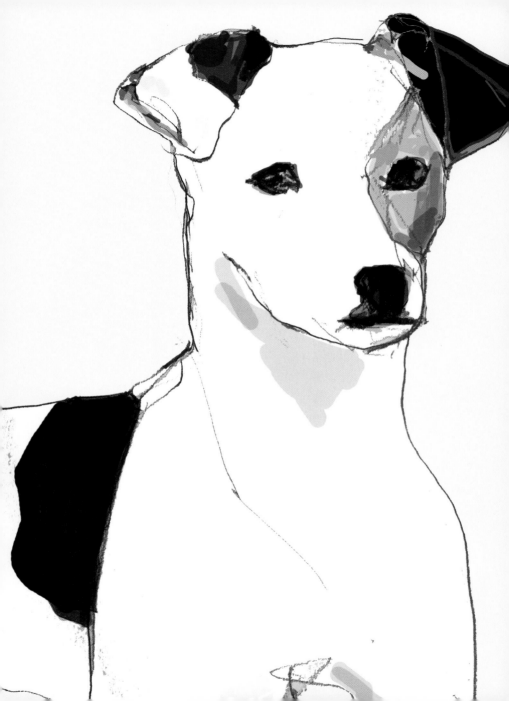

JACK RUSSELL TERRIER

Jack Russells are small terriers
bred by, and named after, Reverend
John Russell, a hunt enthusiast,
to hunt fox in the 1800s.

Small, keen, and full of life,
Jack Russell Terriers are
charmingly affectionate,
coy, confident, and clever
escape artists—born to dig.

Teaching a Jack Russell to
become a civilized companion
is no easy task. It requires time,
patience, and a sense of humor.

Their weatherproof coats are
smooth or rough, mostly white
with tan and/or black markings.

They think they are human and will
fill your days with laughter and love.

Tenacious and tough.

Moose (December 24, 1990–June 22, 2006) was a Jack Russell Terrier
and veteran dog actor, most famous for his portrayal of Eddie Crane on
the TV sitcom *Frasier*. Moose won the role after only six months of training.

"The first thing I do each morning is get out of bed and give my dog,
Audrey, a hug. She's a Jack Russell. I think having an animal is a
wonderful thing, particularly dogs. They are great levelers, there's
no nonsense with them, and they just want simple affection."

—DONATELLA VERSACE

JAPANESE CHIN

In Japan, dogs (*inu*) were viewed as working and helping animals. Japanese Chins, however, were regarded as separate beings (*chin*)— bred solely to be companions of royal and noble blood.

They have a catlike nature— climbing high, mounting furniture, batting objects, using their paws to wash their faces, and hiding in unexpected places.

Chins are deeply sensitive to environments and the emotions of their people.

In a quiet home, they are reserved. In an active home, they are lively.

Their head, face, and forelegs are covered with short hair. Their bodies have black and white coats, silky to the touch— thick manes, feathered ears, and plumed tails.

Dainty and mild-mannered. Talkative, not barky.

Clean.

"I've seen a look in dogs' eyes,
a quickly vanishing look of amazed contempt,
and I am convinced that basically dogs think
humans are nuts."

—JOHN STEINBECK

KERRY BLUE TERRIER

Kerry Blue Terriers are medium-size
dogs from the mountainous area of
County Kerry in Ireland.

Aggressiveness was bred into the
Kerry Blues intentionally—to catch
rabbits and bring badgers to bay—
and unless properly socialized, they
can be aggressive with other dogs.

Kerry Blues are typical terriers—
alert, resourceful, muscular,
and always ready for action.

Puppies are born black,
turning to dark blue, brown,
and gray—and reaching a
blue-gray color at maturity.
They can live as long as
fifteen years.

They have V-shaped ears,
black noses, and a mop of
hair covering their dark eyes.

They are not especially vocal, but
when they bark, they're intimidating.

Exercise and groom daily.
For confident leaders only.

"Dogs love their friends and bite their enemies, quite unlike people,
who are incapable of pure love and always have to mix love and hate
in their object relations."

—SIGMUND FREUD

In 1996, musician Beck's fifth album cover, *Odelay*, featured a Komondor jumping a hurdle.

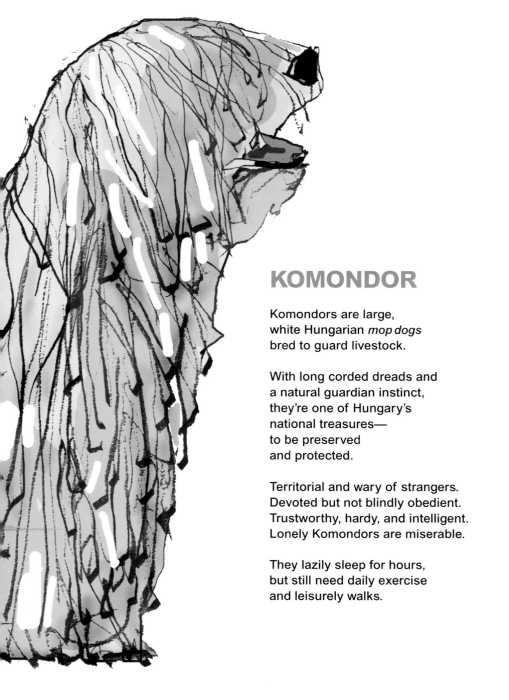

KOMONDOR

Komondors are large,
white Hungarian *mop dogs*
bred to guard livestock.

With long corded dreads and
a natural guardian instinct,
they're one of Hungary's
national treasures—
to be preserved
and protected.

Territorial and wary of strangers.
Devoted but not blindly obedient.
Trustworthy, hardy, and intelligent.
Lonely Komondors are miserable.

They lazily sleep for hours,
but still need daily exercise
and leisurely walks.

LABRADOODLE
(Labrador Retriever / Poodle)

In 1989, Labradoodles were developed
at the Royal Guide Dogs Association of
Australia by breeding manager Wally
Conron to be allergy-friendly guide dogs.

The first cross produced a dog named Sultan.
Sultan had the allergy-friendly coat and the
aptitude, intelligence, and personality to be
an effective working guide and therapy dog.

Labradoodles come in
many sizes and colors,
depending on Poodle size—
Toy, Standard, or Giant—
and Labrador color—
yellow, chocolate,
or black.

Good with children.
Avid swimmers.
Smart and snuggly.

LABRADOR RETRIEVER

Labrador Retrievers are
good swimmers, and with their
webbed toes, otterlike tails,
and their double coats are
weather- and water-resistant.

Voracious eaters, they rarely
turn down food, and with precise
control over their jaw muscles, they
love to hold objects in their mouths.

They bark at strangers to express
joy—not as a warning.

Labradors have a high pain tolerance—
making them ideal for extreme conditions
during rescue and retrieval operations.

They come in three solid colors—
yellow, **black,** and **chocolate.**

"A person can learn a lot from a dog, even a loopy one like ours. Marley taught me about living each day with unbridled exuberance and joy, about seizing the moment and following your heart. He taught me to appreciate the simple things—a walk in the woods, a fresh snowfall, a nap in a shaft of winter sunlight. And as he grew old and achy, he taught me about optimism in the face of adversity. Mostly, he taught me about friendship and selflessness and, above all else, unwavering loyalty."

—JOHN GROGAN, *MARLEY AND ME*

Are black Labs smarter than

chocolates?

Tails are carried high.

LHASA APSO

Lhasa—capital city of Tibet.
Apso—"shaggily bearded."

Originated in Tibet.

For thousands of years,
Lhasa Apsos were bred
exclusively by nobility
and monks to guide and
protect monasteries.

From the beginning of the
Manchu Dynasty in 1583
until as recently as 1908,
the Dalai Lama sent Lhasas
as sacred gifts to emperors
of China and members of
the imperial family.

Lhasas were given in pairs
and believed to bring good
luck and prosperity.

Keen hearing.
A deep bark.
Hidden eyes.
Black noses.
Dense coats.
High tail bones.

Comically entertaining.

"A dog has the soul of a philosopher."
—PLATO

LOWCHEN

Through the centuries,
Lowchens have been
depicted in art around
the world. Today the
breed is relatively
unchanged from what
it looked like many
years ago.

The name *lion dog* comes
from the traditional Lowchen
clip—close-cut hindquarters
and a full, natural mane.

Lively and energetic,
sweet and affectionate—
they will challenge any
dog or rule.

They will take over the
homes, lives, and hearts
of the people they love.

Surprisingly robust.

"What counts is not necessarily
the size of the dog in the fight—
it's the size of the fight in the dog."

—DWIGHT D. EISENHOWER

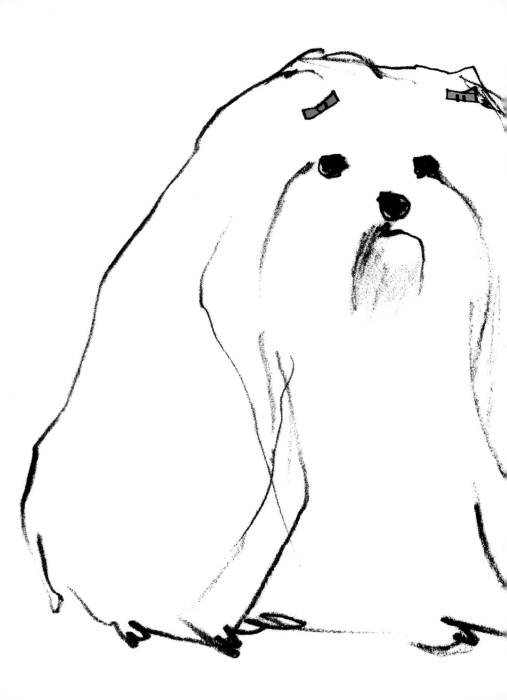

MALTESE

Don't let their tiny stature—
or their weight, just 4 to 6 pounds,
fool you—Maltese are fearless toward
people and dogs of any size.

For more than twenty-eight centuries,
these aristocratic, adorable fluff puffs
have been owned by royals around
the globe.

Although affectionate and loyal,
Malteses can be aggressive with
strangers and snappy with children.

They have silky white coats
and are groomed to appear
dignified and refined.

Brush daily for optimal beauty.

Charles Darwin theorized that
Malteses originated as a breed
around 6000 BCE.

Notable Maltese Owners
Queen Elizabeth
Marie Antoinette
Queen Victoria

MALTIPOO
(Maltese / Miniature Poodle)

Poodles and Maltese are nonshedders—
Maltipoos are bred to be allergy friendly.
Affectionate and gentle, they make cuddly
companions and excellent therapy dogs.

Active, feisty, and fun.
Easy to train. They enjoy
pure affection and are
sensitive to their people's
wants and needs.

"And how many times have I thought that perhaps there is
somewhere (who knows, after all?), to reward so much courage,
so much patience and labor, a special paradise for good
dogs, for poor dogs, for dirty and afflicted dogs."

—CHARLES BAUDELAIRE

LARGE
HUMONGOUS HEAD
BLACK MASK
THICK AND HEAVY
CONFIDENT
GENTLE
GIANT
MASSIVE
MASTIFF

Warning: Training required

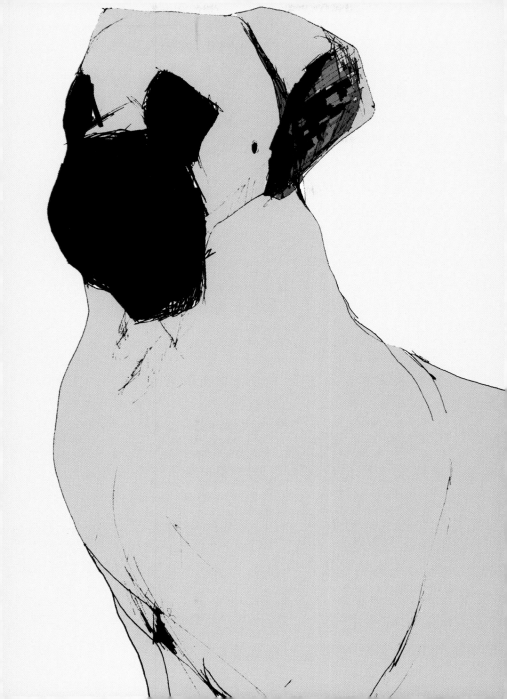

MUTTS

Mutts are the best of all dogs. With all sizes, shapes, patterns, and colors. A long snout or short nose. Prick ears or floppy ones. Stubby tail, a spot on left eye, furry legs—or all three. Love them and your love will be rewarded.

Approximately three-quarters of dogs in shelters are mixed breeds. Adopting a mutt means giving a home to a dog who really needs one.

"The intelligence of a Poodle and the loyalty of a Lassie. The bark of a Shepherd and the heart of a Saint Bernard. The spots of a Dalmatian, the size of a Schnauzer, and the speed of a Greyhound. A genuine, All-American Mutt has it all."

—ASPCA SLOGAN

BENJI

Benji embodies the best qualities of a true mutt— loyalty, intelligence, courage, and good looks. The American Humane Association reported that after the first Benji movie was released and it became known that its star was rescued from an animal shelter—more than 1 million dogs were adopted from shelters across the country. Powerful awareness and publicity generated by one mutt!

"Benji is able to sulk, skulk, peek, pause, do double-takes, worry, frown, scowl, and glint in sly triumph. He is so wordlessly articulate that he should do a film without any two-footed creatures at all trying to steal scenes from that small and extraordinary dog with the soulful eyes."

—LOS ANGELES TIMES

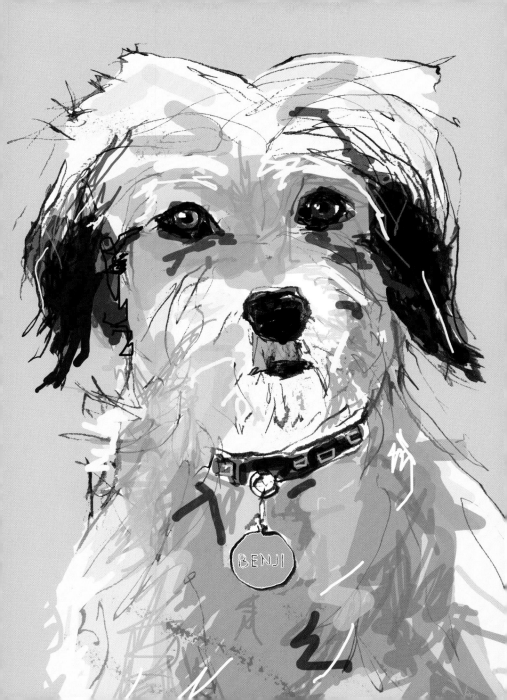

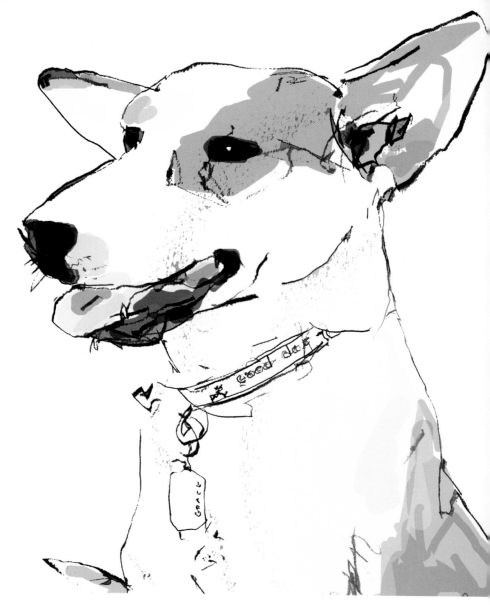

GRACE

Lab – Akita Mix
Grace was saved from a kill shelter in Tennessee, then sent to a shelter in New York City and adopted at the age of two.

CHAMP

Wolfhound – Lab Mix
Champ spent days locked in a basement boiler room, neglected. He was adopted at the age of eleven. Gentle and obedient.

NEAPOLITAN MASTIFF
(Il Mastino, or Neo)

Originating from Naples, Italy—
Neapolitan Mastiffs make a
powerful first impression with
their massive head, hanging
jowls, and imposing nature.

Their slow, rolling gait
is lumbering yet forceful.

An astounding gentle giant.
Their massive size—150 to 200
pounds—loose skin, and thick
wrinkles evoke speechless awe.

Neos are believed to be
more than 2000 years old.
Experts refer to the breeding
of Neapolitan Mastiffs as an art.

However fascinating to look at,
they snore thunderously and
slobber and drool when they
are hot, hungry, or thirsty.

Unaware of their own strength,
Neapolitans must be socialized,
especially with children.

Although wary of strangers, they
rarely bark—unless provoked.
They sneak up on intruders.
Standing and staring.

A Neopolitan Mastiff has set the record—giving birth to twenty-four puppies!

NEWFOUNDLAND

Newfoundlands (Newfies) are
gentle, giant dogs of 120 to 150
pounds, from Newfoundland, Canada,
originally used as working dogs—
pulling nets for fishermen.

Webbed paws and thick coats make
them strong swimmers, and their
swimming style is similar to the
breast stroke (not a doggie paddle).

Rescuing drowning swimmers
from rough seas or hauling wood
from forests—Newfies are capable
hard workers on land and sea.

Protective and patient—
lovable teddy bears
who adore children.

"A man is not a good man to me because he will feed me if I should be starving, or
warm me if I should be freezing, or pull me out of a ditch if I should ever fall into one.
I can find you a Newfoundland dog that will do as much."

—HENRY DAVID THOREAU, *WALDEN*

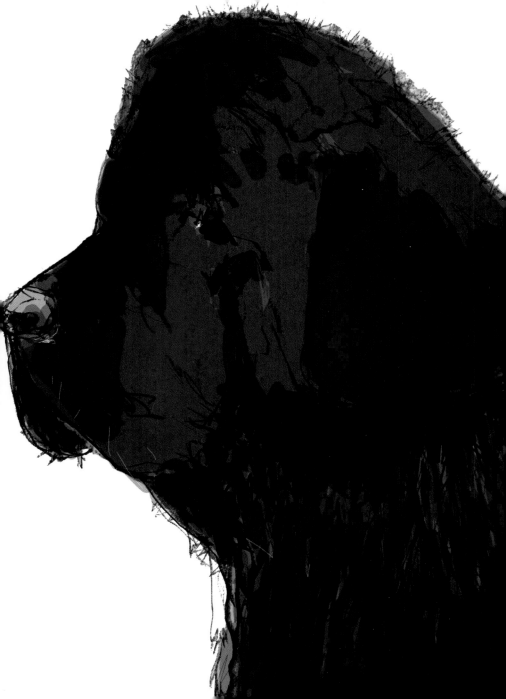

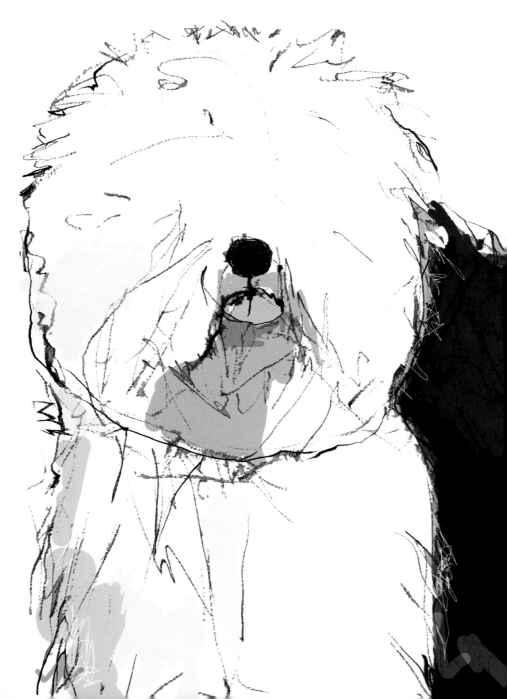

OLD ENGLISH SHEEPDOG

Shaggy Old English Sheepdogs
are easygoing and fun loving.

They are large—60 to 80 pounds—
sturdy herding dogs with puffy
blue, gray, and white coats, making
them appear even bigger.

A playful sense of humor and
good-natured kindness make
them excellent with kids.

Bouncing and pouncing.

"The Frolicking Nanny" is
a term of endearment for
Old English Sheepdogs.

Fictional Old English Sheepdogs
Barkley—*Sesame Street*
The Colonel—*101 Dalmatians*
Edison—*Chitty Chitty Bang Bang*
Farley—*For Better or For Worse*
Max—*The Little Mermaid*

OTTERHOUND

Otterhounds are large,
shaggy scent hounds
who nearly disappeared
after hunting otters
became illegal in Britain.

With tousled coats,
Otterhounds look like
mutts, but they are an
old and rare breed.

Big, hairy, messy eaters
and drinkers, they love to
get klutzy, muddy, and wet.

Otterhounds weigh anywhere
from 65 to125 pounds. Amiably
affectionate yet independent.

With their deep, baying voices,
they're communicators, *talking*
to their people with mutters,
grumbles, grunts, and sighs.

Calm by nature but not lazy.

Brush and comb coat weekly.
Clean beard after every meal.

Today there are fewer than 1,000 Otterhounds—
350 to 500 of them reside in the United States.

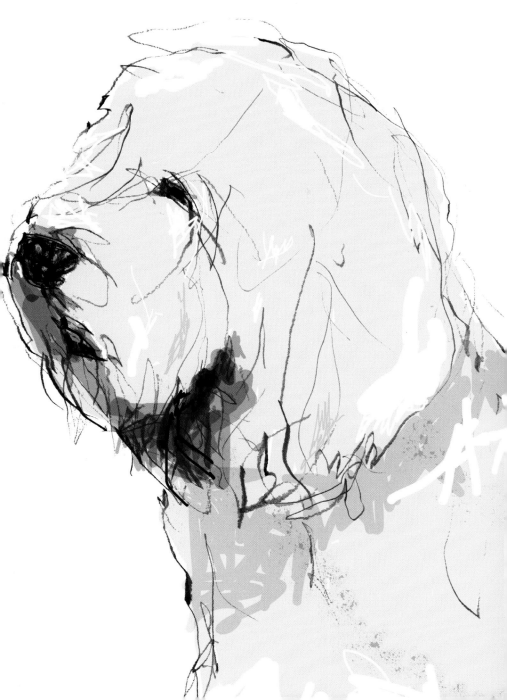

PAPILLON and PHALÈNE

In French, *papillon* means "butterfly."
Papillons are named for their large,
fringed, ears, obliquely carried—
moving like the spread wings of
a butterfly. When the dog is alert,
each ear forms an angle of approximately
45 degrees to the head.

Their drop-eared siblings are called
Phalènes, from the French word for
"moth"—a cousin of the butterfly
that folds its wings at rest.

Both types can be born in the same litter.
Papillons are the more recognized ones.

They are categorized by size as lap dogs—
but busy Papillons and Phalènes are more
likely to be flitting around than sitting on laps.

Despite being only around 4 to 9 pounds,
Papillons and Phalènes have big-dog traits—
energetic, fearless, and sturdy.

Their coats are easy to care for
and do not shed excessively.

Papillons live long lives and
tend to have small litters.

In 1999, Ch. Loteki Supernatural Being (Kirby), a Papillon, won Best in Show
at the Westminster Dog Show—contributing to the breed's rise in popularity.
They are not a rare breed, but not common, either.

When Lauren Bacall died in August 2014, she left $10,000
to maintain the care of her beloved Papillon, Sophie.

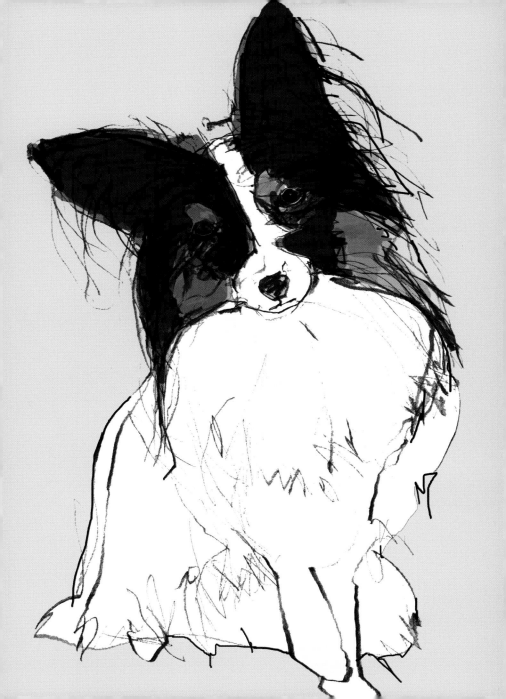

PEKINGESE

Pekingese are believed to
have existed in China for
as long as 2,000 years.

Named after the capital city of
Peking (now Beijing), they were
companions to nobles and princes.
Commoners bowed to them.

With soft brown eyes, long
straight manes, and tails
carried jauntily over their
backs, Pekingeses are
intelligent and independent—
with a stubborn streak.

Don't poke Pekes—
they will defend
themselves.
Children beware!

Pekingeses tend to
be one-person dogs
and need owners who
understand them. They
especially enjoy the
company of other Pekes.

Affectionate.
Loving.
Brave.

Nicknames
Fu, Pekes, the Sleeve dog, *Ha pa* (under table) dog, Lion dog,
Symbol of Buddha, Pelchie, Butterfly lion, and Temple dog.

Folklore legend holds that this breed came from the Buddha, who made them tiny so they could chase little demons loitering around the temples.

PIT BULL

Combining the strength of English Bulldogs
with the fearless nature of terriers, Pit Bulls
were bred to fight other dogs and animals.

Despite their history and reputation,
Pit Bulls do *not* make great guard dogs.
They are trusting of humans and greet
intruders as friends.

Historically, Pit Bulls have proven
to be gentle with children, playing with and
watching over them. They are affectionate
and make proud therapy dogs for patients
recovering from emotional or physical trauma.

Pit Bulls were so respected in the early 1900s,
the military chose an image of a dignified Pit
Bull to represent the country on World War I
propaganda posters.

Once known as America's Dog, Pit Bulls could
now be called America's Most Abused Dog. High
numbers of these misunderstood companions
are tortured in dogfighting rings or chained up
and neglected by those who want *scary-looking*
guard dogs. Unfortunately, this trend has led to
the breed's unearned reputation for violence.

High intelligence.
High sniffing abilities.

The biggest drug bust ever at the Hidalgo, Texas, port of entry was made thanks to
a Pit Bull named Popsicle. Popsicle located over 3,000 pounds of cocaine in Texas.

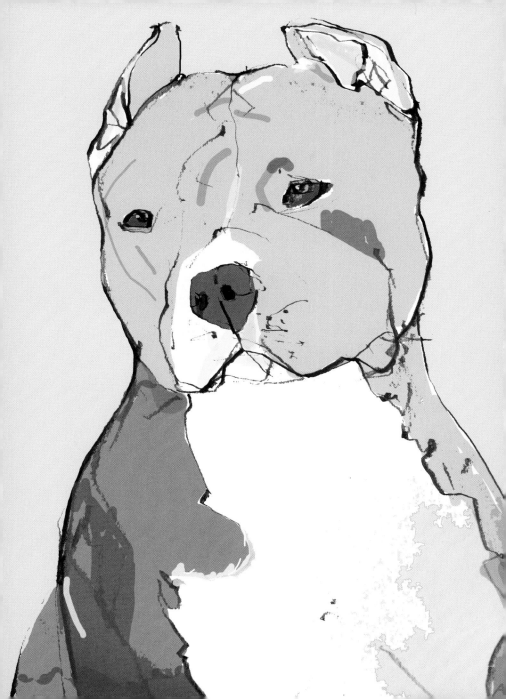

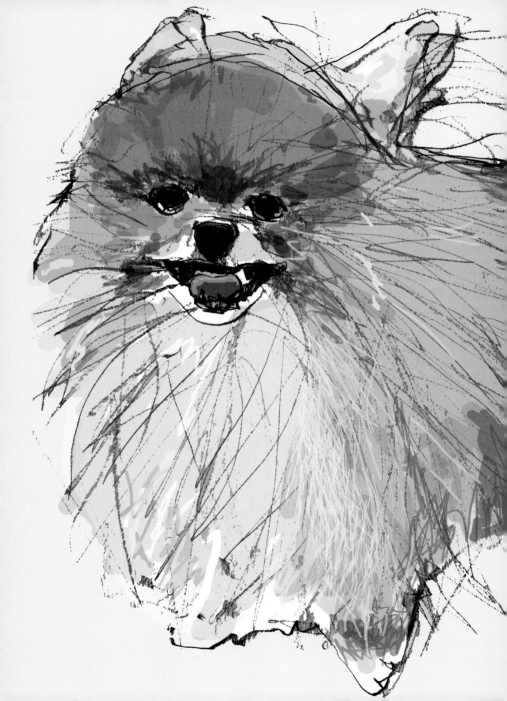

POMERANIAN

Pomeranians (Poms) are foxy-face dogs, of 3 to 7 pounds, with big personalities. Their name comes from the province of Pomerania, in Germany.

Cute, feisty, furry,
compact and sturdy,
independent and bold—
Poms think they are giants,
often antagonizing large dogs.

Socialization is required.

Perky erect ears,
sparkly almond eyes,
wedge-shaped heads.
Dark noses, fluffy coats,
plumed fanning tails.

Poms come in solid colors:
red, white, orange, cream,
brown, black, and blue.

Notable Pomeranian Owners
Michelangelo
Isaac Newton
Mozart

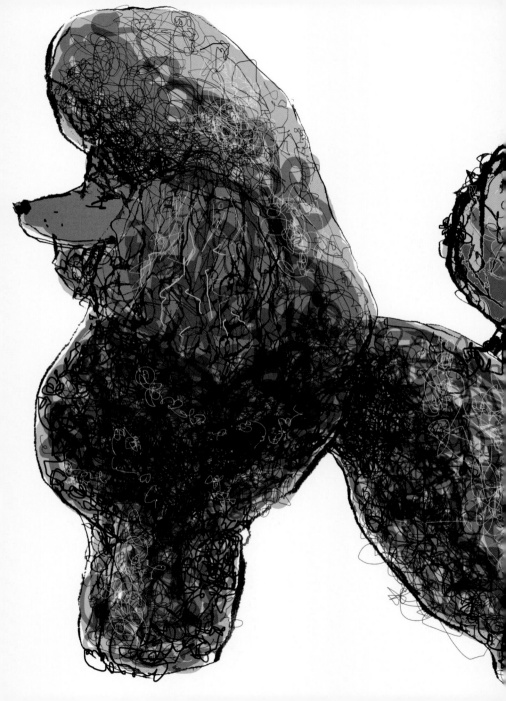

POODLE

Despite their regal air, ancient history, and over-the-top hairdos, Poodles are not snobs.

Poodles were bred to retrieve waterfowl for hunters. Their name is derived from the German word *pudeln*, which means to splash in water. In France, they are called c*aniches*, meaning "duck dogs."

Their elaborate coats served a practical purpose. Trimmed areas lightened their weight, preventing underwater snagging. Long hair on the legs and torso protected their joints and major organs from cold water.

Poodles come in three sizes:
Toy, Miniature, and Standard.

They are known for their pride
and keen intelligence—excelling
in performance sports, obedience,
and agility.

Their dense, curly coats come
in many colors; blue, black, white,
gray, silver, brown, café-au-lait,
apricot, and cream.

Clean their weepy eyes.
Groom them for optimal
beauty and health.

Notable Poodle Owners
John Steinbeck
Gertrude Stein
Victor Hugo

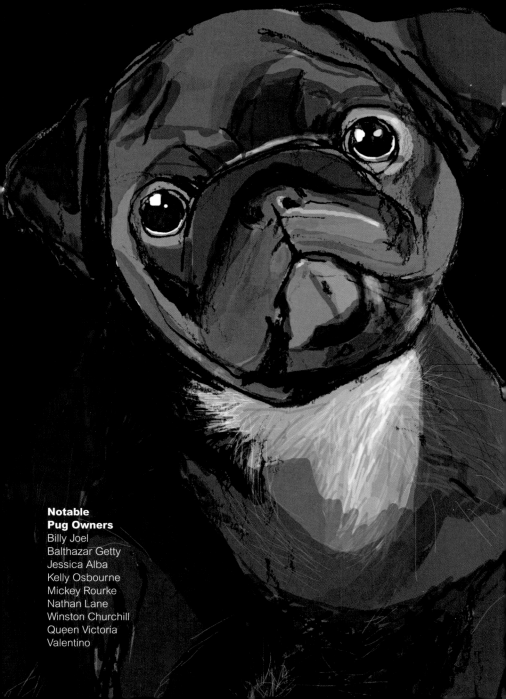

**Notable
Pug Owners**
Billy Joel
Balthazar Getty
Jessica Alba
Kelly Osbourne
Mickey Rourke
Nathan Lane
Winston Churchill
Queen Victoria
Valentino

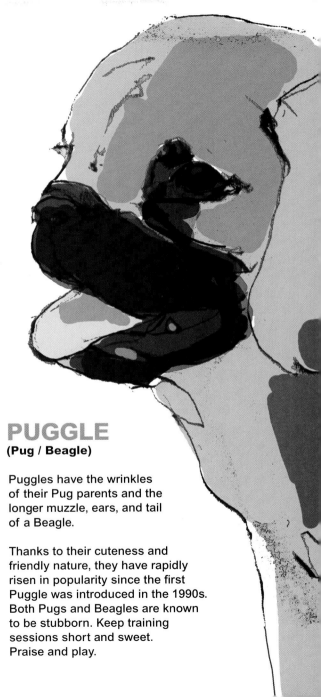

PUG

Pugs originated in China, where they were adored by the emperors and lived in the lap of luxury.

Playful and peppy—
or peacefully calm. . .
Excited and lively—
or lazily napping. . .

Pugs are small and thick with short muzzles, large round eyes, curly tails, and a face full of wrinkles.

They follow closely, like shadows.

PUGGLE
(Pug / Beagle)

Puggles have the wrinkles of their Pug parents and the longer muzzle, ears, and tail of a Beagle.

Thanks to their cuteness and friendly nature, they have rapidly risen in popularity since the first Puggle was introduced in the 1990s. Both Pugs and Beagles are known to be stubborn. Keep training sessions short and sweet. Praise and play.

PULI

Pulis are still used for
herding sheep in Hungary.

They can typically herd flocks
of four hundred or more—
little tornadoes whirling
around, guiding the flock.

Shepherds take great pride
in Pulis' abilities, saying,
"They are not dogs, they
are Pulis."

Self-confident.
Highly intelligent.

Their corded coats can
take four years to grow in
completely. They come in
solid colors of black, rusty
black, and all shades of
gray and white.

Underneath all that hair,
they weigh 25 to 30 pounds
and stand 16 to 17 inches tall.

"Dogs never bite me, just humans."
—MARILYN MONROE

RHODESIAN RIDGEBACK

Rhodesian Ridgebacks were once known as African Lion Hounds. They originated in Rhodesia (now Zimbabwe) in Africa.

Settlers crossed Great Danes, Mastiffs, and Greyhounds with indigenous native African dogs—the result was a breed of dogs that had a distinct ridge of hair down their back.

They were bred to be versatile hunting dogs who could protect property; withstand rough terrains; and run down a lion, harass it, and prevent it from bolting until a hunter arrived.

Today, Rhodesian Ridgebacks are found competing in sports—agility, obedience, and tracking. They make great hiking and jogging companions.

Rambunctious and exuberant as puppies—maturing into quiet, gentle dogs with moderate exercise needs.

Large—70 to 85 pounds—protective, and wary of strangers, Ridgebacks will position their body between their people and a perceived threat.

Sometimes imposing.
Sometimes sensitive.

"Nothing but love has made the dog lose his wild freedom, to become the servant of man."
—D.H. LAWRENCE

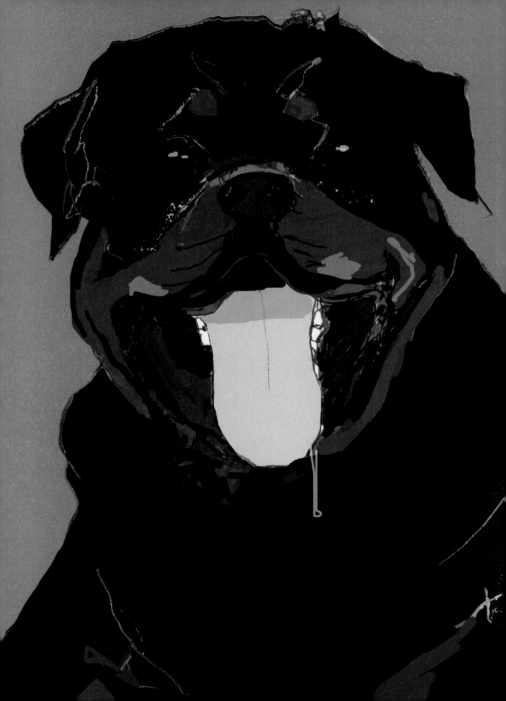

ROTTWEILER

Originating in Germany,
Rottweilers (Rotties) are
protective and true.

With their broad chests
and muscular bodies, they
display confidence and
strength in their movements.

At 85 to 150 pounds, these
guards were designed to
protect. With a bite force
of 328 pounds, Rotties are
intimidating, fearless, and
vigilant with strangers.

Vigorous workers—
in search and rescue,
in service and therapy,
at police precincts,
in tracking and
on farms.

Eyes filled with kind love—
mouths filled with drool.

For determined owners.
They require trust and respect.

"If you pick up a starving dog and make him prosperous,
he will not bite you. This is the principal difference between
a dog and a man."

—MARK TWAIN

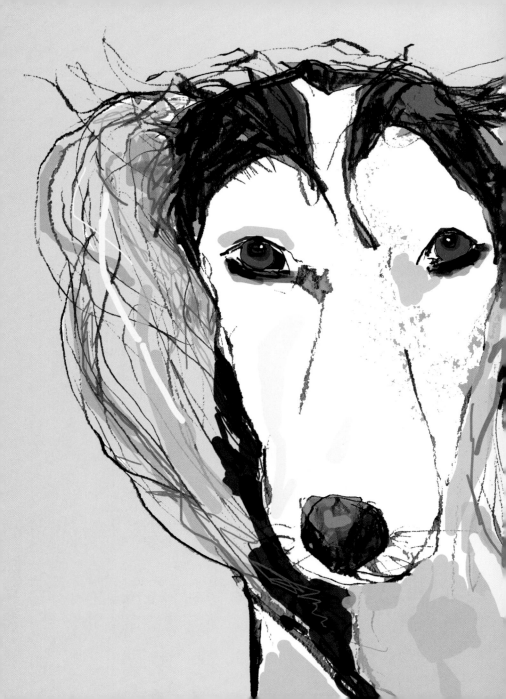

SALUKI

Salukis are sight hounds who historically traveled through the Middle East with nomadic tribes from the Sahara Desert to the Caspian Sea and China. They were used to hunt gazelles and hares.

Salukis are loved for their exotic appearance and grace. They are sleek, fast, and quietly devoted. Their coats are smooth or feathered.

They are fearless hunters not to be trusted off a leash: Any subtle movement triggers their instinct to chase, at up to 35 mph—otters, foxes, raccoons, squirrels, deer— frequently capturing and killing their prey.

Salukis can jump over or dig under a fence. They love romping, running free, and sleeping on pillows.

If lonely or stressed, Salukis howl and bay, but rarely bark.

They kiss with their noses.

SAMOYED

Pronounced
"*Sammy*-ed" or "Sa-*moy*-ed."
Nicknamed Sammies or Sams.

Samoyeds date back 3,000 to 5,000 years.
They are one of the fourteen ancient breeds
identified through a study of the canine genome.
Originating in Siberia, Russia, Sammies played
an important part in daily life with nomadic
Samoyedic people—sledding and herding reindeer.

Samoyeds are known for
their famous Sammy smile.

They are clean, odorless shedders.
The Samoyedic people spun the dogs'
sheddings into yarn for clothing to keep
themselves warm in their cold and
snowy environment.

Sammies keep their coats bright
white by self-grooming like cats.

They are known to talk or sing when
spoken to—often responding with a
low warbling sound —neither a growl
nor a bark.

"There stood the dogs tied up, making a deafening clamor.
Many of them appeared to be well-bred animals—long-haired,
snow-white, with up-standing ears and pointed muzzles. With
their gentle, good-natured looking faces they at once ingratiated
themselves in our affections."
 —FRIDTJOF NANSEN, LEADER,
 NORWEGIAN POLAR EXPEDITION 1893–96

On Roald Amundsen's expedition to the South Pole, his Samoyed
sled dog Etah was the first member of the team to reach the pole.

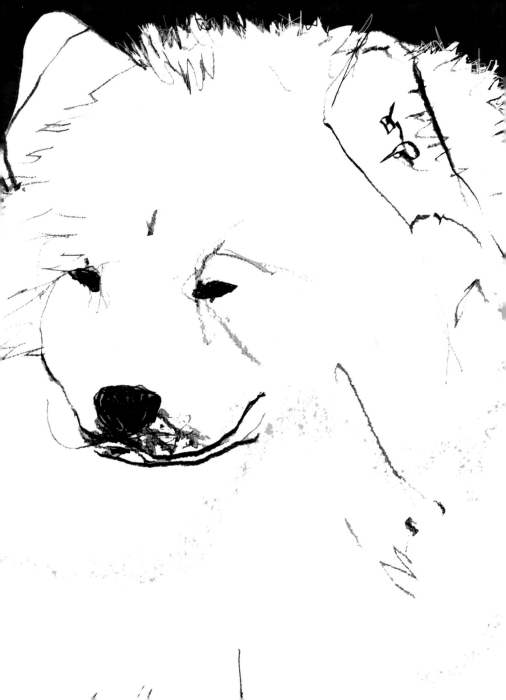

SCHNAUZER

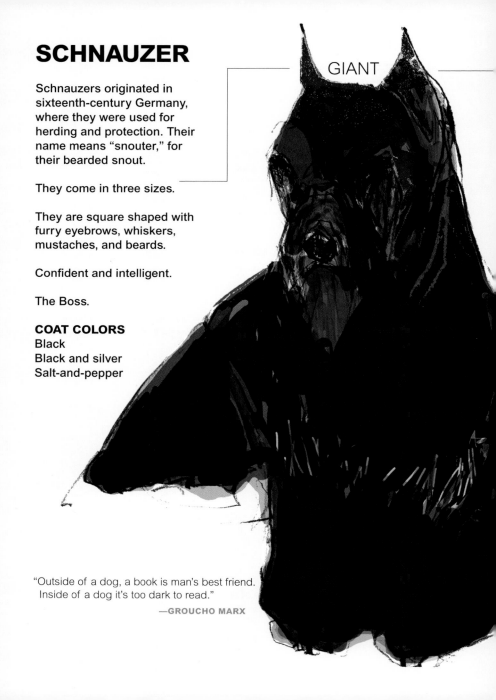

Schnauzers originated in sixteenth-century Germany, where they were used for herding and protection. Their name means "snouter," for their bearded snout.

They come in three sizes.

They are square shaped with furry eyebrows, whiskers, mustaches, and beards.

Confident and intelligent.

The Boss.

COAT COLORS
Black
Black and silver
Salt-and-pepper

GIANT

"Outside of a dog, a book is man's best friend. Inside of a dog it's too dark to read."
—GROUCHO MARX

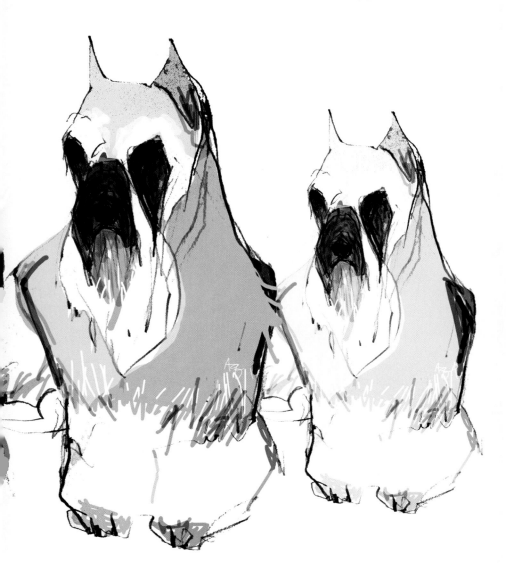

SHAR-PEI

Shar-Peis are medium-size dogs,
45 to 60 pounds, from ancient China.
They were used to guard, hunt, and
sometimes fight.

Shar-pei means "sand skin"—
referring to their distinct bristly coat.
They are covered in folded, loose skin
and have dark purple tongues, powerful
square heads, triangle-shaped ears,
thick curly tails, and padded muzzles.

Calm.
Independent.
Strong willed.
Protective and
devoted.

For bold leaders only.

In 1973, a Hong Kong businessman named Matgo
Law saved the Shar-Pei breed by introducing them
to Americans through a dog magazine. Two hundred
Shar-Peis were brought to the United States. Today's
Shar-Pei population stems mainly from these original
two hundred.

In 1978, Guinness World Records gave the title
"Rarest Dogs in the World" to Shar-Peis.

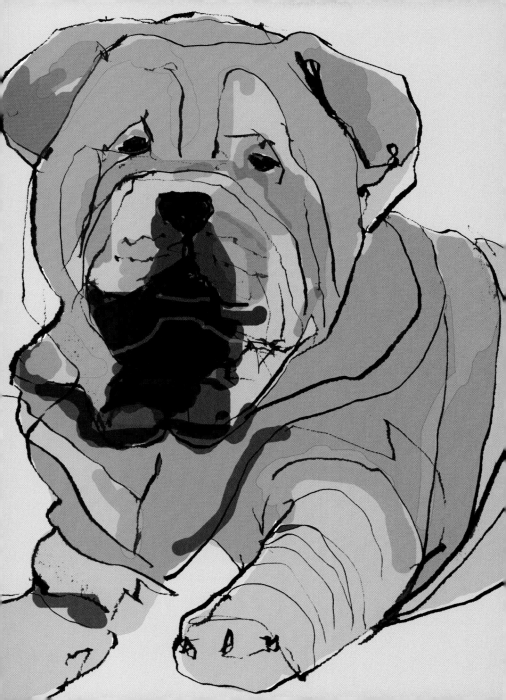

SHIBA INU

Shiba Inus are the smallest
and most ancient of dogs
that originated in Japan.

With their prick ears,
squinty eyes, and curled
tails, this breed looks like
a plush toy fox.

Shibu Inus are freethinkers
and highly intelligent—they
don't always obey commands,
and they possessively guard
toys, food, or territory.

Their strong-willed ways can
be challenging, but enthusiasts
say that owning a Shiba Inu isn't
just owning a dog—

it's a way of life.

Small at roughly twenty pounds
and athletic, Shiba Inus are like
ninja warriors—moving nimbly
and effortlessly.

"Number one way life would be different if dogs ran the world:
All motorists must drive with head out window."

—DAVID LETTERMAN

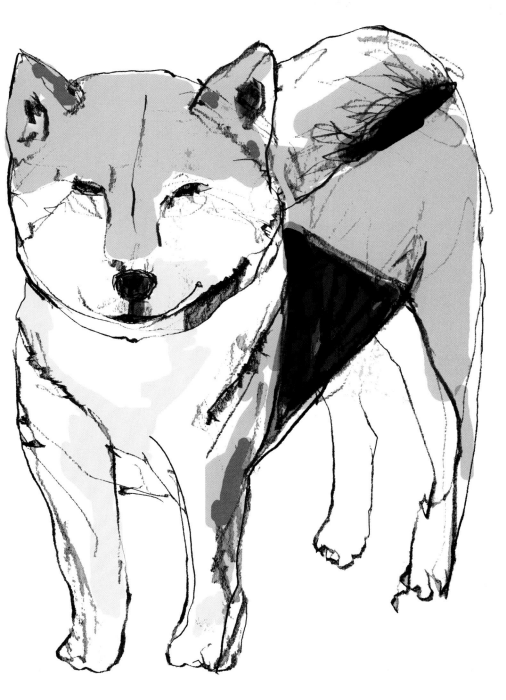

SHIH TZU

Pronounced "*Sheed*-zoo" or "*Sheet*-zue,"
Shih Tzu means "lion dog" in Chinese.
The dogs' hair grows outward from the
center of their faces, making them resemble
little lions. Chinese paintings, dating back to
500 BCE, depict dogs believed to be Shih Tzus.

Tibetan monks considered Shih Tzus sacred
and holy. They lived in Buddhist temples,
working with the monks as alarm dogs.
They also served as companion dogs for
the royal family. Today, Shih Tzus are one
of the best-loved dog breeds in America.

A sentinel dog.
Peevish when provoked.

"I think dogs are the most
amazing creatures; they give
unconditional love. For me,
they are the role model for
being alive."

—GILDA RADNER

SKYE TERRIER

Originating more than four centuries ago on the Isle of Skye in Scotland, Skyes are an old breed.

They were used to hunt badgers, foxes, and otters by following them into burrows— and pulling them out.

Skye Terriers can be aggressive toward unfamiliar dogs and will chase and stomp on smaller pets.

They have two coats protecting them from harsh weather and injury:

a soft, short undercoat; a hard, straight topcoat. Brush and trim to avoid knotty tangles.

WARNING: Small-dog syndrome— the dog believes it is the humans' pack leader. Bossy and willful.

ST. BERNARD

St. Bernards are large working dogs
originally bred by monks to guard the
grounds of their hospice at Switzerland's
Great St. Bernard Pass.

St. Bernards have been credited with
rescuing more than 2,000 injured or stranded
travelers during three centuries of recorded
hospice records. In the early 1800s, one
St. Bernard, named Barry, saved over forty
lives. They're nicknamed "Barry dogs."

Carrying a barrel of brandy
around their neck is a myth.

Giant—
200 pounds—
majestic, and sacred.

Brainy, even tempered,
nonterritorial, and loyal.
They thrive in colder
climates.

Although portrayed as galloping troublemakers,
full-grown St. Bernards are mellow and calm.
Keep them active with daily walks and training.

The movie *Beethoven*, starring Chris, a St. Bernard, grossed a
total of $147.2 million worldwide and was followed by numerous sequels.

TIBETAN MASTIFF

Developed centuries ago in Tibet, be mindful of Tibetan Mastiffs— they start out as cute, teddy bear puppies and grow into dogs that weigh 90 to 160 pounds.

With their massive appearance, massive coat, and massive tail, Tibetan Mastiffs are sure to turn heads and start a conversation.

Tibetan Mastiffs are loving, patient, and understanding. They're independent guardians wanting to be treated as equals, not pets.

They enjoy company and are sensitive to human moods— becoming upset during family conflicts and loud arguments.

"I like any dog that makes me look good when it stands next to me."
—JEAN HARLOW

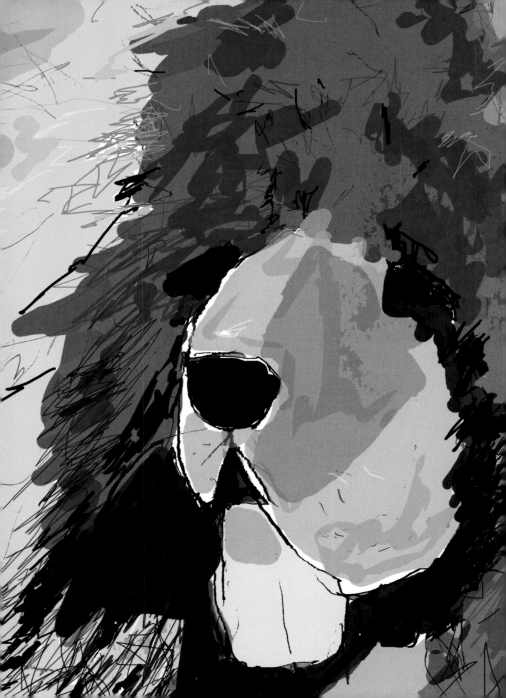

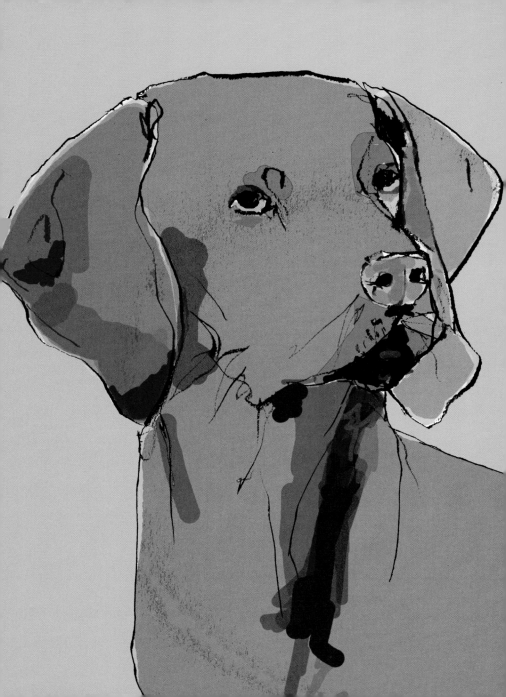

VIZSLA

Pronounced "*Veesh*-la,"
Vizslas originated in Hungary.
Otherwise known as Hungarian
pointers, they were used by nobles
and warlords to hunt wolves, deer,
hare, wild boar, and more.

When the Russians invaded
Hungary after World War II,
Vizslas nearly faced extinction.
Fortunately, they managed to
survive and were brought to
the United States in the 1950s.

Often described as "Velcro Vizslas",
they are attached to their people—
following closely, leaning against
your leg or sitting on your feet.

Vizslas are versatile and stylish,
with rusty shaded coats.

Lean and athletic.
Obedient by nature.

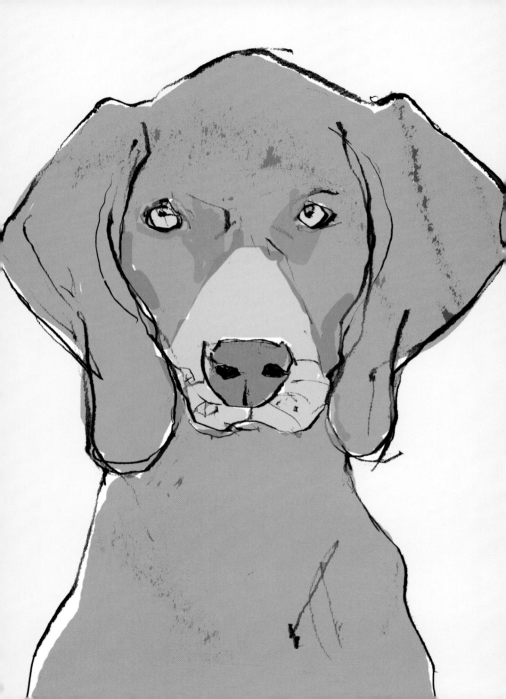

WEIMARANER

Weimaraners are a fairly young breed,
dating back to early-nineteenth-century
Germany. These dogs were bred for speed,
sensing ability, and endurance while
hunting big game like bear and deer.

They are affectionately called
Weims or Gray Ghosts—
for their sleek silver coats
and pale blue eyes.

Gorgeous.
Courageous.
Fearless.

These dogs have loads of
energy and stamina. They
need exercise and mental
stimulation. Without it—
they are rambunctious!

Gentle yet firm training
creates a true family friend.

William Wegman is a photographer who uses wigs, costumes, and props
to capitalize on Weimaraners' ability to portray humanlike expressions.

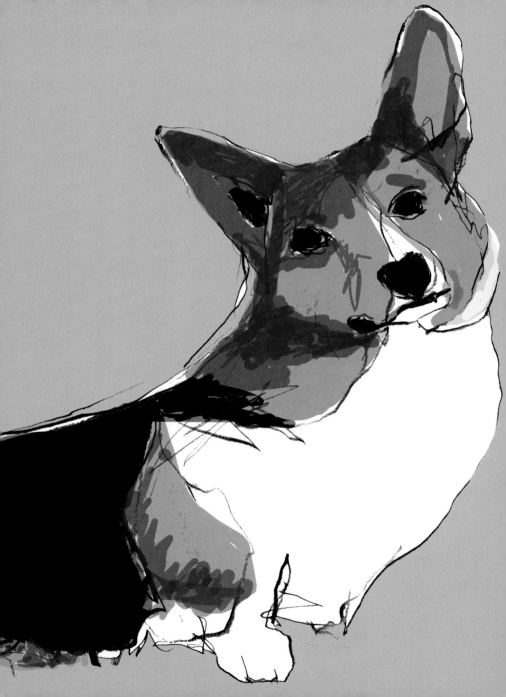

WELSH CORGI

Known as the Fairy Dog of Wales—
enchanting Welsh Corgis have
been loved by the British royal
family for over seventy years.

Her Majesty, Queen Elizabeth II
of England, received her first
Pembroke Welsh Corgi from her
father (King George VI) in 1933.

Approximately a foot tall,
Corgis are the smallest
of the herding breeds.

Long bodies,
stubby peg legs,
erect triangle ears,
and slender muzzles—
nipping and nudging
your ankles.

Highly intelligent.
Always walking tall.

"One of the most obvious ways dogs can improve
our physical and mental health is via daily walks."

—DR. ANDREW WEIL

WEST HIGHLAND WHITE TERRIER
(Westie)

West Highland White Terriers are
Scottish-bred, sturdy little dogs—
robust, friendly, and spirited.

City apartments or country houses—
Westies love living indoors with family.
Small animals that run free—rabbits,
hamsters, or gerbils—are in danger
when a Westie is near.

On long vacations or short errands,
Westies are willing and easy travelers.
They hike, romp, play, and watch the house—
give them toys, music, and a crate.

Self-assured, confident, and quick.

Notable Westies

On the animated series *King of the Hill,*
the Souphanousinphone family's pet is
a Westie named Doggie.

Coconut is a Westie that appears in the
American Girl series of books and dolls.

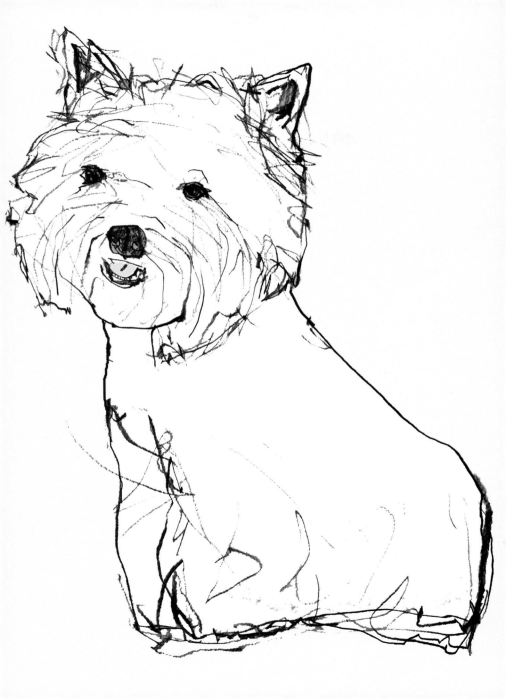

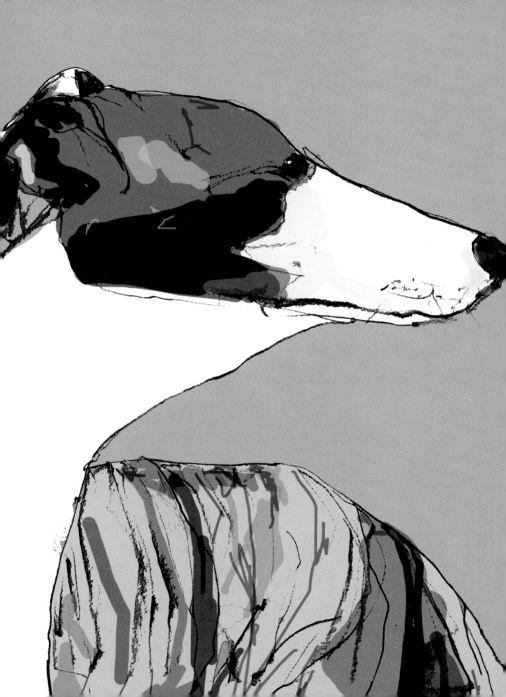

WHIPPET

Whippets were developed by crossing
Greyhounds with smaller terriers—
resulting in sleek, elegant dogs
who are gentle and affectionate.

These medium-size hounds have
short coats covering their streamlined
bodies and long muscular legs.

The breed's name comes from the
phrase *whip it*, meaning "run fast,"
perfectly describing the 35 mph
running speed of Whippets.

Despite being bred for racing,
Whippets are content sleeping
the day away like *couch potatoes*.

When touched unexpectedly—
they jump!

Long heads, oval eyes, small ears,
tapered muzzles, black noses, and thin
lips. They carry their tails between
their legs when relaxed—never
above their backs.

Quiet, intelligent, and gentle.

Whippet Nicknames
Poor man's Greyhound
Rag dog
Snap dog

YORKSHIRE TERRIER
(Yorkie)

Oblivious to their tiny seven-
pound size, Yorkies are big in
personality. Their silky blue
and tan coat; glamorous,
perky topknot; and diva
ways attract attention.

They often travel in style—
first-class, fancy bags.

Known for their loyalty, they
will challenge opponents ten
times their size when threatened.
Despite their bravado, Yorkies
crave attention and love.

Do not spoil them.
Do not overprotect them.
Give them squeaky toys.

They are born black,
gradually changing
to blue and tan.

Yorkies have single-layered
coats of hair, not fur.

Notable Yorkies

In the original *Wonderful Wizard of Oz* book, illustrated by W.W. Denslow, Toto was a Yorkie. However, in the film, Toto was played by a Cairn Terrier.

During World War II, an American soldier found a Yorkie puppy in a foxhole. She was named Smoky and went on to become an American war hero. Smoky visited injured American soldiers, making her the first official therapy dog. She survived 150 air raids in New Guinea and a typhoon in Okinawa and once parachuted from a thirty-foot tree with a parachute designed just for her.

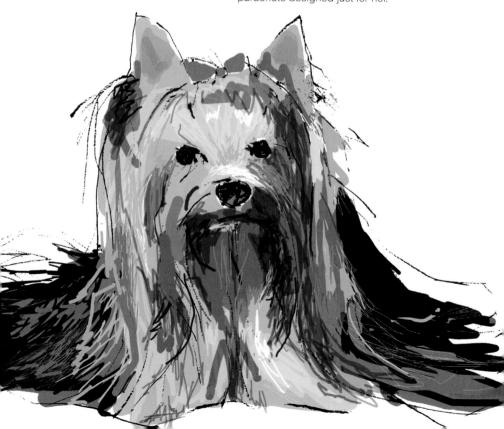

"I consciously choose the
dog's path through life.
I will remain a dog,
I shall be poor;
I shall be a painter."
—VINCENT VAN GOGH